It Speaks to Me

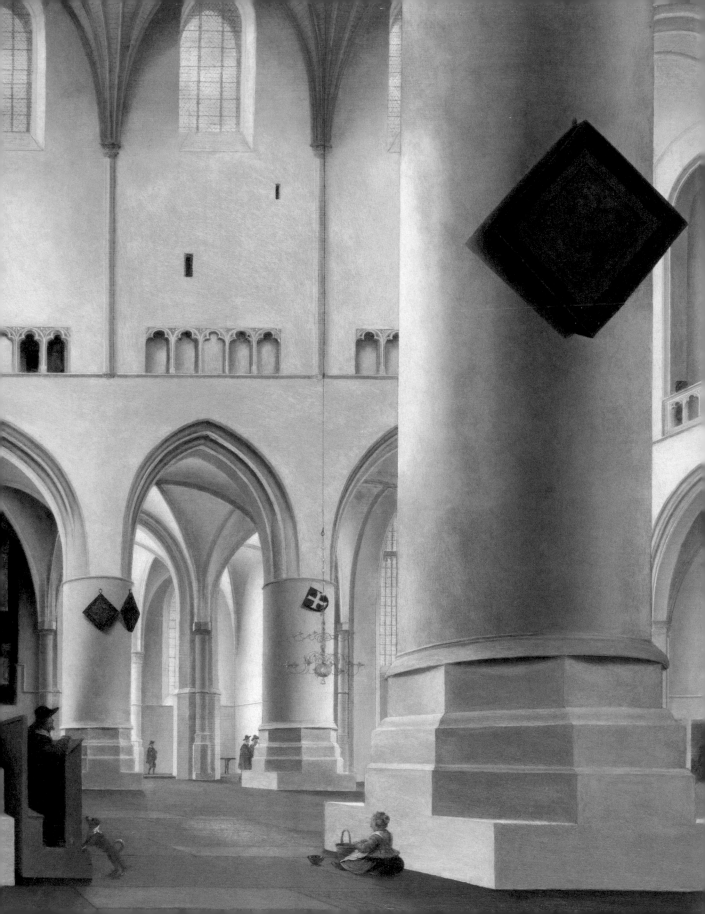

It Speaks to Me

Jori Finkel

Art That Inspires Artists

DelMonico Books · Prestel

MUNICH · LONDON · NEW YORK

Contents

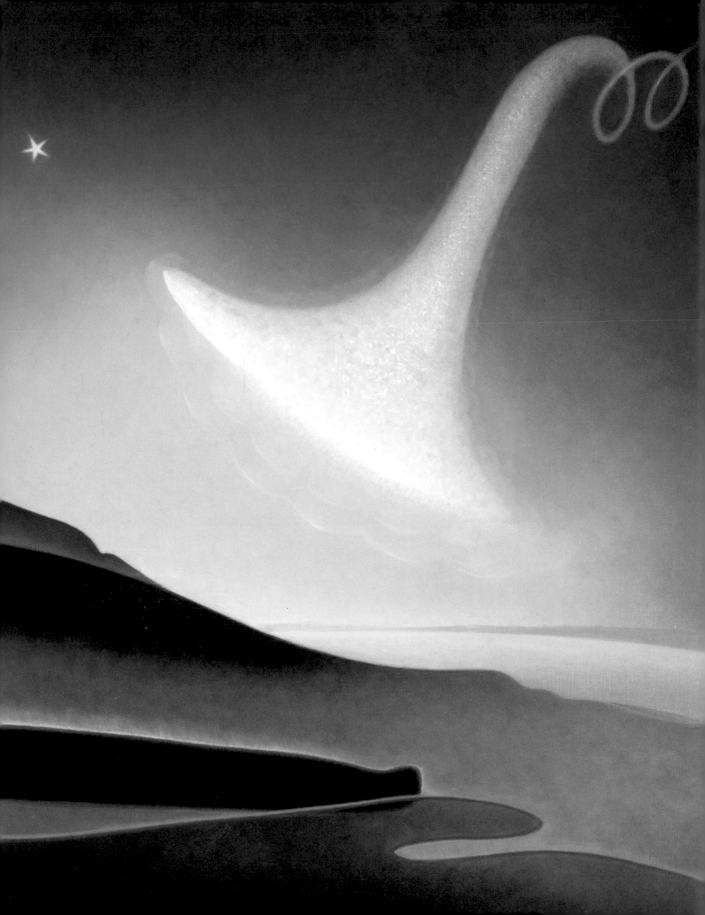

Introduction

Jori Finkel

As someone who reads the fine print in life, I've long had a love-hate relationship with museum wall labels: those printed panels you see hanging alongside artworks. To the extent they make works of art more accessible, they can make the museum itself more inviting. But they too often fail to meet that goal. In the field, they're called "didactics," which may give you a sense of where they can go wrong.

Some are overloaded with historical detail, conveying information on the obscure duke who commissioned the painting centuries ago or the possible identity of the portrait sitter that only doctoral students would appreciate. Others are wooden, written in a flat, explanatory style that takes all the juice out of the artwork.

This book is meant to do the opposite, bringing us closer to works that might historically, geographically, or just visually—what is that strange trumpetlike image by Agnes Pelton anyway?—seem foreign. How can a painting or sculpture made 700 years ago or 7,000 miles away reach us today? What about that big, yellowing lump of wax by Joseph Beuys? What does it mean, and why does it matter?

For *It Speaks to Me*, I interviewed fifty artists around the world about artworks they find inspiring. They chose a wide range of works, from Asian antiquities to a twenty-first-century American social-protest drawing about immigration and deportation. They chose recognized masterpieces by Mark Rothko and Robert Rauschenberg and also little-known pieces by Cézanne and Degas. (David Hockney selected perhaps the least recognizable Degas—his copy of a Poussin painting.) Both Canadian artists in the book chose work by indigenous artists—an inventive Tlingit bentwood box from the nineteenth century and a witty political assemblage by Anishinaabekwe artist Rebecca Belmore from 1987. Both artists from Mexico City discussed Aztec sculptures.

Not only did their particular choices prove interesting, but I found the way they entered and understood the artworks fascinating too. Their conversations, by turns direct and meandering, personal and intellectual, offer examples of how we, too, might find something meaningful and memorable in a work of art. Much as a good film review gives us, beyond the thumbs up or down,

an example of someone sharing what he or she most wants from a movie, these interviews give us examples of artists thinking out loud about how to make the most of art.

I started by choosing artists who have inspired me, whether world-famous or still emerging, young or old, figurative painters or video artists or those harder to classify. I started with curiosity. In my work as a cultural journalist over the last twenty years, I've followed a great range of artists. Who would I most like to hear speaking about a work of art that moves them?

It's safe to say across the board that the artists I interviewed are not known as the definitive experts on the artists they selected. They have not authored the important scholarly essays or edited the comprehensive catalogues raisonnés on their chosen artists. But they bring another kind of authority to bear.

Visual artists are by and large experts in seeing. According to the most recent scientific studies, the museumgoer spends an average of twenty-nine seconds in front of a "masterpiece," and that includes the time it takes to snap a selfie. In my experience, artists who go to museums have different habits of perception and attention. Maybe they breeze past one work but linger in front of another for ten or twenty minutes. Maybe they pass over the so-called masterpieces altogether in favor of some little celebrated gems. And in some cases, the artists are collectors themselves, as you will discover about Ai Weiwei, who has over the years quietly accumulated what is debatably the world's best private collection of jade objects and in this book speaks about a very early and rare example of a kneeling jade figure from the Shang Dynasty.

Contemporary artists are also experts in scavenging: finding in other art, and in the world at large, whatever can be of use to them in their own work. Sometimes these debts go unacknowledged, and Harold Bloom in *The Anxiety of Influence* makes a persuasive argument as to why artists bury their most important sources—part of a larger attempt to position themselves as original. But sometimes artists will at least hint at a connection between their own work and that of another artist.

Several do in this volume. Luc Tuymans openly grapples with the legacy of Jan van Eyck: one of the greatest painters in the history of Belgium coming to terms with another. Judy Chicago finds in Agnes Pelton, via Georgia O'Keeffe, the foundations of a profoundly female or feminist abstract art, abstraction used to express an artist's inner reality. Mark Bradford, known for bringing social issues of race and class into abstract painting, talks about all that Mark Rothko's surface beauty gave him as a teenager—and has failed to give him since. Gillian Wearing, who has wonderfully complicated the tradition of portraiture by making photographic self-portraits while disguised as other people, talks about an unflinchingly honest self-portrait that Rembrandt made in the last year of his life.

At one level, then, *It Speaks to Me* is a collection of inspiring objects chosen by some of the most compelling artists working today, designed to offer insight into the artwork chosen and perhaps also the artist doing the choosing. At another level, it's a collection of travel tips for what to see in museums in different cities around the world. I go on TripAdvisor for booking hotels, and I use Yelp to find restaurants and services near me—I even found a new dentist that way. But too many

of these user-generated, review-based websites shortchange us when it comes to cultural recommendations and resources.

Read the numerous reviews of the Getty Center on TripAdvisor and you will find many suggesting that you take a tour of the Getty gardens. Few mention that they were designed by artist Robert Irwin, or why. And none will guide you, as Bill Viola does here, through the upper level of the Getty's North Pavilion exhibition hall to find a fifteenth-century painting of the Annunciation by Dieric Bouts. It's an important religious painting of the Virgin Mary, but Viola has an even more expansive read, calling the subject "probably the most profound in human existence: the moment when a woman knows she's pregnant."

Thinking about the book this way, as a sort of idiosyncratic and highly personal guide for art worth seeing in different cities, helped shape the way I approached the interviewing process. Instead of asking an artist to speak about his or her "favorite" artwork—as if there were only one favorite—I asked each artist to discuss a museum piece that intrigues or inspires them from their hometown. What might you show a friend visiting from out of town?

The thinking is that we as readers could step into the shoes of that friend. We can share in the excitement of discovering a new work or seeing a familiar work in new light. And we can do this vicariously from the comfort of our own reading chair or more directly by visiting these museums and seeing the works for ourselves.

Of course, this isn't always feasible, and not just because flights from Los Angeles to London and from Chicago to Chiang Mai are expensive. Most art museums like to refresh and rehang their permanent collections galleries, so even valued artworks can go into storage for a while, or on loan to other institutions. But by focusing on artworks belonging to museums and not private collectors, my hope was that you might be able to see some of this art in person one day.

As a journalist, I've been fortunate to make a living out of following artists and their thinking. I've found it inspiring to walk through museums, studios, city streets, national parks, and hardware stores with them, attempting to see, to some degree, through their eyes. I hope you enjoy this chance to follow their lead as well.

Artists on Art

Marina Abramović

on Umberto Boccioni's
Unique Forms of Continuity in Space

1913 (cast 1931). Bronze, 43 ⅞ × 34 ⅞ × 15 ¾ in. (111.2 × 88.5 × 40 cm)
The Museum of Modern Art, New York

I'm always most interested in the people who really change the way a society thinks and perceives, and there are very few artists in any century who have done that. For the twentieth century, I think about Duchamp, Malevich, Rothko, Giacometti, and Boccioni.

To me, Boccioni and the Futurists are interesting because of their devotion to technology, cars, speed, and velocity, all these extremely modern things. Great art has always been made on the ruins of something old, and the Futurists arrived like fresh air in the early twentieth century. But unfortunately, because they were promoted by Mussolini and connected to Fascism, they were never seen in the right light. I think when the stigma wears off, there will be interesting discoveries.

For me, what Boccioni really succeeded in doing was presenting the energy in movement. He figured out how to visualize energy, how to give physical and material form to something invisible and immaterial. He helps us see something we haven't seen before.

This sculpture looks so abstract, almost Cubist, but it's really a human figure walking, showing how you leave energy behind as you move through space. It's not very large, but at the same time you have the feeling of an immensity. It's like the tiny Giacometti figures that actually fit in your hand but can hold a big, empty museum space because the energy is so condensed.

My mother was an art historian, and I've known about this piece for a long time. I saw it in books and photographs when I was in my twenties still living in Yugoslavia. But there's nothing like seeing it in person—certain works react with your nervous system, your entire being.

My own work in performance is also based on immateriality and energy. When I did *The Artist Is Present*, I had a strong sensation of the energy of people. When they stood up and left the chair, their energy was still there. It just stayed there, becoming layers and layers of energy. When you're very sensitive and in a high state of concentration, you can perceive that.

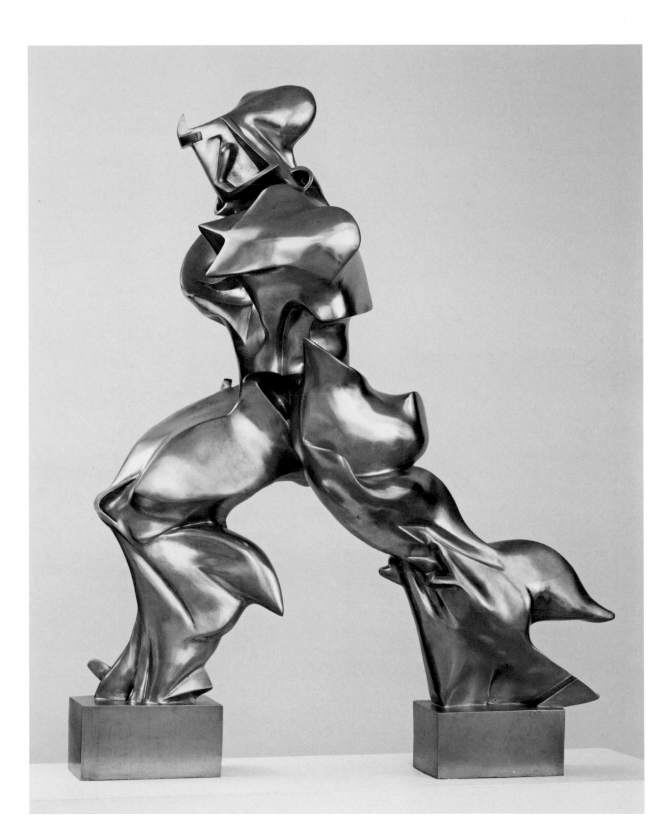

Ai Weiwei

on a Shang Dynasty jade from the tomb of Fu Hao

1300–1046 BCE. China, Henan Province, Anyang
Jade, height 2 ¾ in. (7 cm)
National Museum of China, Beijing

My interest in classical Chinese artifacts started very late because I grew up during the Cultural Revolution, and the Communist Party was trying to erase ancient traces from Chinese history. They were trying to destroy the older culture to establish the new world. You couldn't have a jade piece at that time; it would be confiscated or you would be destroyed yourself.

Growing up I really only saw one piece of jade—a seal given to my father before he went into exile that had five characters on it: "If you know how to endure hardship, you might find the way." He later tried to smooth down the characters for fear the words would give him away. It wasn't until 1993, when I moved back to China from the U.S., that I really started going to antiques markets to buy jade. Beijing has an ocean of antiques. Now I probably have one of the largest jade collections.

This kneeling figure comes from the tomb of Fu Hao, the most complete archaeological discovery made by the Chinese government, one undisturbed by tomb thieves. Fu Hao was a remarkable military leader, maybe the most powerful female ruler in that period of Chinese history. Archaeologists found 755 jade pieces in her tomb, which speaks to her status. Jade is a very hard stone, so think about the amount of time and energy needed to carve these pieces—this incredible manpower.

Some people believe this small carving represents Fu Hao herself, but I believe it's more mythological than memorial in function—a ritual object related to a higher power. The piece protruding from her back looks like a fishtail, which would mean she's a god or ghostlike figure. In the Shang Dynasty, you often saw depictions of humanlike figures with a dragon's head or a fish's tail. They are images of transformation. The kneeling position is common, but the tail and headdress are unique; they don't repeat in thousands of objects that come later.

Jade carries such weight in Chinese culture that every dynasty has used it. In the Chinese language, there are a few hundred words just to describe the qualities of jade, whether black, fine, small, or transparent. This figure is an example of white jade, so it has this feeling of translucency and softness. When you touch it, it's extremely smooth, like silk.

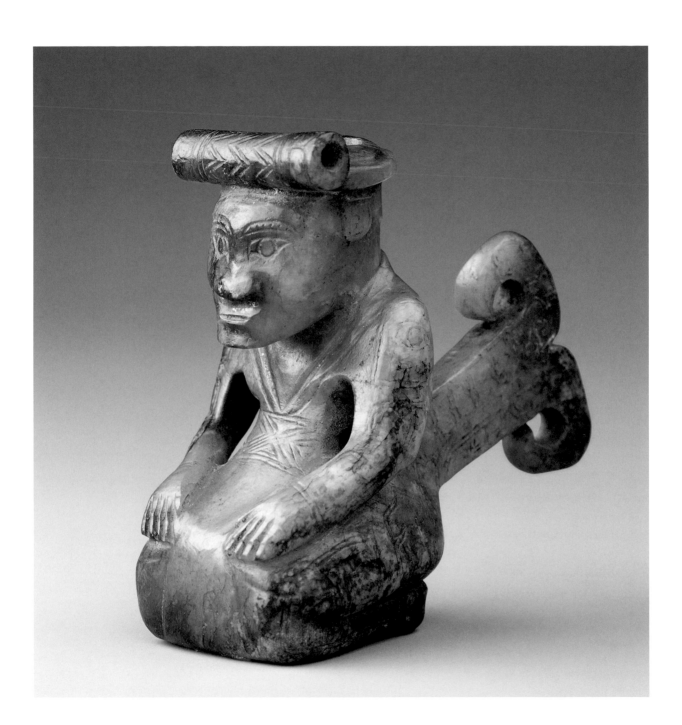

Leonor Antunes

on John Knight's *The Right to Be Lazy*

2009–present. Site-specific and time-based landscape installation, variable dimensions
Hamburger Bahnhof, Berlin

Joseph Beuys is one of the key artists at the Hamburger Bahnhof: they have some of his important pieces. But the work that I find most striking is outside the museum.

There is some landscaping outside the museum, on either side of the main entrance, and the whole environment is quite German, so to speak, with all the little bushes perfectly shaped and organized, all very symmetrical and properly conserved. Except for one area: the round garden near the entrance, where John Knight's project is situated. Knight is a California artist known for site-specific installations and was commissioned to make work here in 2008. With the exception of basic nutrition, he asked the gardeners and institution to let this part of the landscape flourish, no cutting or pruning.

Nowadays the perfectly round bushes that were there are gradually changing shape, and everything else is messier and wild. The grasses have grown so high they have started to bend into funny shapes, and every blade of grass has its own way of moving. It looks totally neglected. There's a metal plaque in the area with a caption and the title of the work: *The Right to Be Lazy*.

The piece acts on many different levels. You start to pay attention to everything around you, how the park is organized, how gardeners trim the bushes, how landscape is sculpted over the years with the need to remain always in the same shape, as if nothing had changed. The roundabout is the only spot where you can see the effects of time since this piece was "activated."

The work also acts as a critique of museum hierarchies and politics in a way. I see it as a commentary on the tasks that we normally overlook when visiting museums and on the employees that get overlooked, like gardeners.

I think *The Right to Be Lazy* is also a manifesto written for artists, reminding us not to overproduce and fill the market with artwork. It's a reminder of how we can do so much with so little.

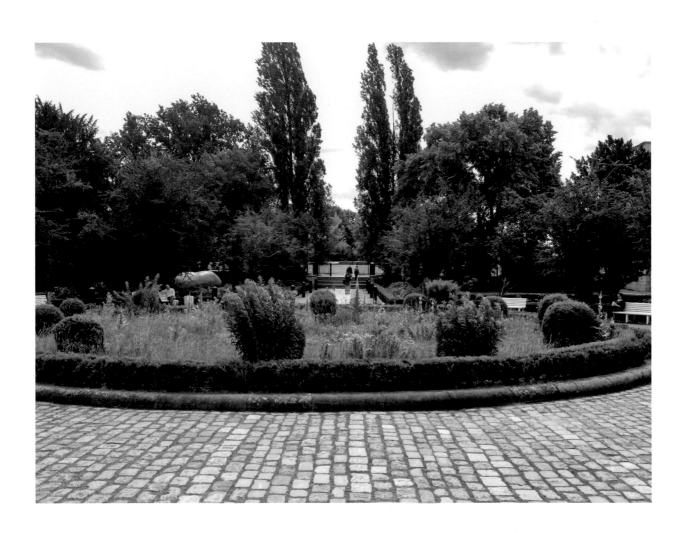

Ilit Azoulay

on the Ivory Pomegranate

Date disputed. Ivory, height 1¾ in. (4.4 cm)
The Israel Museum, Jerusalem

My first encounter with this object was when I was doing my BFA studies in Jerusalem, probably in 1992. It's a very small object in the form of a pomegranate, made from a hippopotamus tusk. It's only 4.4 cm tall, but you couldn't miss it. It was on display inside two vitrines, one inside another, with a guard standing by. It was so well protected, this was the *Mona Lisa* of The Israel Museum.

It's easy to understand why the museum valued it. There have been a lot of arguments regarding the First Temple of Jerusalem, whether it physically existed, and here was evidence that it did. The pomegranate bears a short Old Hebrew inscription: "Sacred to the priest of the House of God." It was discovered in 1979 in a Jerusalem antique shop and quickly became very famous, appearing on the cover of books about the First Temple.

I came to the object again recently, while working on a three-year project at the museum that took me into its inner depths. I was surprised to find the pomegranate bowl in storage, just loose in a box.

What I learned is that the object was found in 2004 to be fake. Researchers found the forms of the letters were suspect, and they discovered through scientific analysis that the patina was a more modern imitation and that the tooth itself is not from the Iron Age but most likely from the Late Bronze Age.

I would still imagine an object like that wrapped in a very particular fabric, inside a box, inside a storage compartment with a key. But this was just loose in a storage cupboard. I was allowed to touch it. Also in the box was a replica of the object. It turns out that when the Israel Museum exhibited the pomegranate, they didn't exhibit the original—it was too valuable. Now the hierarchy between original and replica has collapsed, there is no difference between them, both asleep in a drawer.

There are a few historians who haven't entirely given up and still make arguments for the authenticity of the Ivory Pomegranate. What interests me is how this little object carries such weight on its shoulders. The war over its narrative is the same war that is so embedded in Israel's history and everyday life. Living in this country, we suffer from a constant "territorial disease," with borders always changing and being rewritten. I think if we were living in a place with peace, this object wouldn't be so charged.

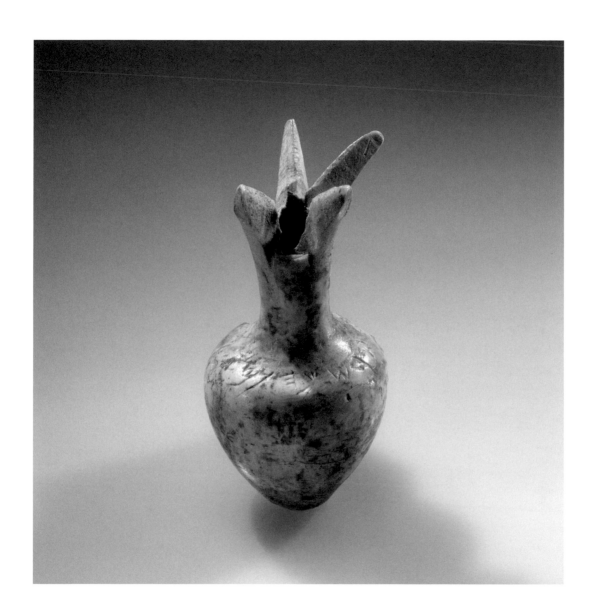

John Baldessari

on René Magritte's
The Treachery of Images (This Is Not a Pipe)

1929. Oil on canvas, 23 ¾ × 31 ¹⁵⁄₁₆ × 1 in. (60.3 × 81.1 × 2.5 cm)

Los Angeles County Museum of Art

This is not a very good painting. You can hardly even tell it's a painting—you can't make out any brushstrokes. I would call it an illustration, and like Norman Rockwell images, it looks better in reproduction than in actuality.

It's not a great painting, but it's a great lesson of a painting. It's a great teaching device. I've always felt that a word and an image are of equal value, and that's certainly what this painting is about.

I think about my own piece in the LACMA collection, *Wrong*, also a balance of visual and verbal information. It's the image where I'm standing in front of a palm tree and there's just one word below: WRONG. Kodak used to have a printing guide of common picture-taking mistakes. One of the things it said is don't stand in front of a tree, it would look like the tree is growing out of your head. And I kind of liked that.

Now I don't know if kids today know what a pipe is, besides something you smoke dope in, and Magritte's pipe is certainly not one of those. It would be more au courant to say this is not a cigarette, maybe.

I used to smoke pipes—I have a collection of maybe fifty pipes in storage. I'm more likely to smoke cigars now.

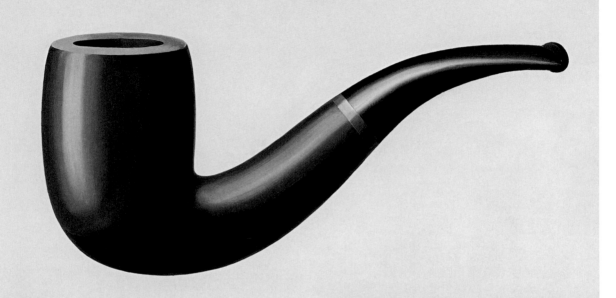

John Bock

on Joseph Beuys' *Tallow*

1977. Tallow, grease, plaster, thermocouplers, voltmeters, transformers, and steel

Hamburger Bahnhof, Berlin

The story about this work is that Beuys found this dead space in Munich and wanted to fill it with beeswax. It was this strange wedgelike cavity between a pedestrian underpass and a ramp to a university building, where some homeless people lived. He wanted to show his art in dead spaces to bring some warmth to the city.

But it was too complicated politically to make there, so he solved the problem by making a huge wood model of the cavity to use as a mold and filled it with a mixture of wax and beef fat. He cut the shape into six sections and found an old thermometer to put in one of the blocks and measure the temperature of the beef fat.

The chunks look like huge ice blocks, but they are warm inside: 26 degrees Celsius or 79 degrees Fahrenheit. He is showing us with the thermometer that the sculptures are organic and contain energy. This work is not dead, so its heat could change: it speaks in heat language.

Fat and felt were important materials to Beuys. The legend goes that in 1944 his plane was shot down over the Crimean Front and Tartar tribesman saved his life by feeding him butter and wrapping him in felt. Other people keep treating the story as fact, but he never said directly that this experience was real; he called it a vision. The reality is he had this crash and twenty-four hours later he was in the hospital.

What this shows me is that Beuys is more interested in creating his own myths and rituals that connect people to nature than in art history. He hated the idea of a cold artwork. Think about Jeff Koons making a shiny, expensive flower that says "don't touch me" and "be careful when you transport me—I'll kill you if there's a scratch."

Beuys is just the opposite. He uses raw, dirty materials, and the shape flows like the mind flows or like the idea flows. That's also very important to me, and it's why I do lectures, performances, and movies. I'm not interested in preserving the sculpture but in smearing my language on it. My sculptures have scratches.

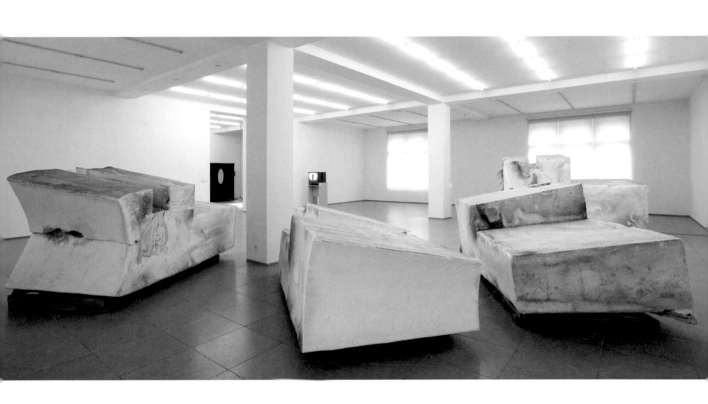

Mark Bradford

on **Mark Rothko's** *No. 61 (Rust and Blue)*

1953. Oil on canvas, 115 ¼ × 92 × 1 ¾ in. (292.7 × 233.7 × 4.4 cm)

Museum of Contemporary Art, Los Angeles

I had a print of this painting in my room when I was a teenager living in Santa Monica. My mother bought it from a poster store and it had a white aluminum frame, which at the time felt high class. I think she bought it to add a splash of color to the room. I remember the blue and red pigments bleeding through to the surface, and it was the first thing that I saw in the morning. I also stared at it at night going to sleep. I stared at the work a lot, lying in my bed, not looking at it with an artist's eye but unfamiliar with what I was looking at, and that made me curious. I didn't even question if Rothko was a white man, for me it didn't matter. For me there was a foreignness: something had appeared that I had not seen before, and that was enough to keep me staring and wondering about its origins.

I didn't know the whole Rothko mythology then: the romantic-modernist tormented painter who committed suicide. I didn't know his role in the New York scene of the 1950s. And I wasn't seduced by the spirituality, what I later saw in the Rothko Chapel in Houston. But I remember looking at it and thinking I wanted to do that; I wanted to make surfaces.

Later on, after reading about his work when I was a student at CalArts, I remember looking at the painting again and feeling that this history could move on a little. I could see how much is not there, not many women and few people of color. By turning my gaze outward and bringing to my work issues of race, gender, and class, I've always wanted my work instead to exist as ideas pulled through the lens of abstraction. Rothko's *No. 61* was a great modernist work, which appeared in my room one day and just as effortlessly disappeared again, replaced by posters of Grace Jones.

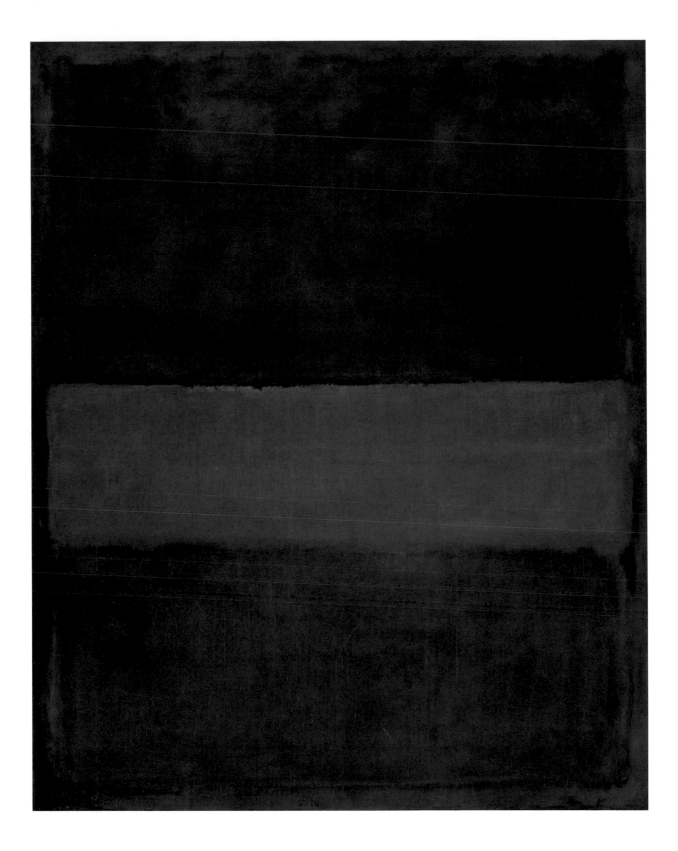

Pia Camil

on an Aztec statue of Coatlicue

1325–1521. Andesite, 61 × 50 ⅜ in. (155 × 128 cm)
National Museum of Anthropology, Mexico City

Coatlicue is an earth goddess, like the goddess of all goddesses in Aztec culture. The most popular variation of the legend goes that she is the mother of Huitzilopochtli, the sun god, and became pregnant with him through a miracle. She's sweeping the floor of a temple, doing penance of some sort, when a ball of feathers falls on her lap, impregnating her.

At this point, her daughter Coyolxauhqui seeks revenge on her mother for getting pregnant. She and her siblings are about to behead their mother when Huitzilopochtli is miraculously born, in full armor, just in time to save her. He kills and dismembers Coyolxauhqui, sending her head into the sky to become the moon. He eventually represents the sun.

So you see in this large statue a beautiful image of a woman with two serpents for a head and two serpents as arms. She wears a skirt made of serpents, which is what *coatlicue* means. She also has an amazing necklace that represents life, a chain of hearts and hands, while her belt is fastened by a skull.

To me what's striking is how the sculpture combines beauty and darkness, or birth and death. I've seen the sculpture at various points in my life, but when I was pregnant with my second daughter I was really struck by its power—I felt the entire power of femininity, the monstrosity of maternity, was with me.

And the history of this sculpture is a history of Europeans being unable to deal with this power. The Coatlicue statue was found buried near what is now the Zócalo in Mexico City on August 13, 1790, just a few months before the Aztec Sun Stone was found. So the Spaniards then seized on the Sun Stone as proof that they had not conquered a barbaric culture, as many thought, but a very advanced civilization with knowledge of math and astronomy. They soon put it up in full view on the outside of Mexico City's biggest cathedral.

It was the opposite with Coatlicue. They found the figure so monstrous and powerful that they essentially hid her away in a remote courtyard of a university. And when indigenous people and mestizos found her anyway and started worshipping her and bringing her flowers, the Spaniards buried her again. It's such an interesting metaphor for male versus female knowledge.

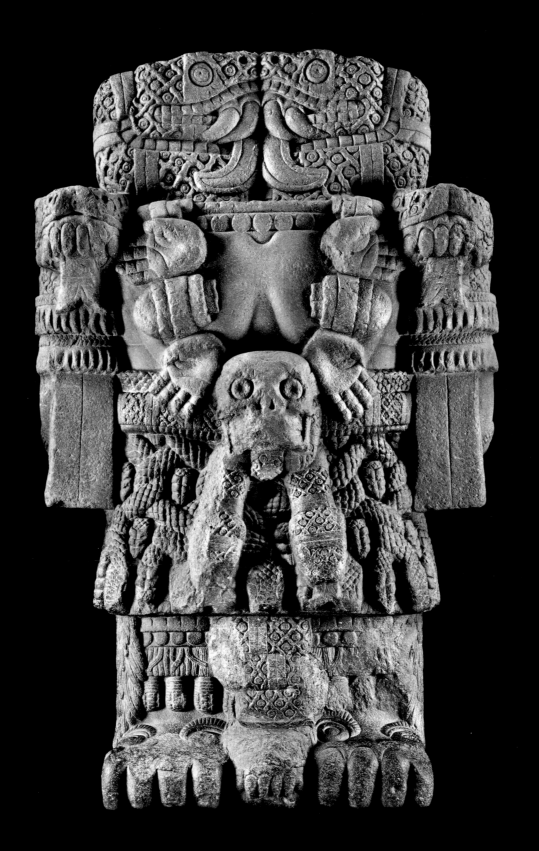

Nick Cave

on Jasper Johns' *Target*

1961. Encaustic and newspaper on canvas, 66 × 66 in. (167.6 × 167.6 cm)
Art Institute of Chicago

What strikes you right away about this painting is its graphic appeal: its directness, its simplicity, its boldness, and the sense of urgency created by using the three primary colors—red, blue, and yellow.

The red is used for the background, but it doesn't stay in the background. It pops forward and is very strong, which makes the image even more alarming, more threatening. Could the red be blood?

Johns made many targets in many mediums—prints, paintings, and drawings. But the size of this particular painting makes it even more disconcerting, more overwhelming. It's bigger than you are, and that scale, I think, increases the level of confrontation and emotion.

What's great is that Johns is not telling you what it's about. If you look at this object, you would never know it's associated in art history with Johns being a homosexual who felt targeted somehow when he made this series in the 1950s and '60s. I like that we can all look at it and relate to it: whether we are women dealing with sexual misconduct or immigrants being singled out or people affected by gun violence. We've all been the subject of violence in one form or another.

I'm using the image of a target right now in my work in this way too: it's not pinpointing what the violation is or who is being violated but exposing the whole dynamic of targeting and the feeling of vulnerability.

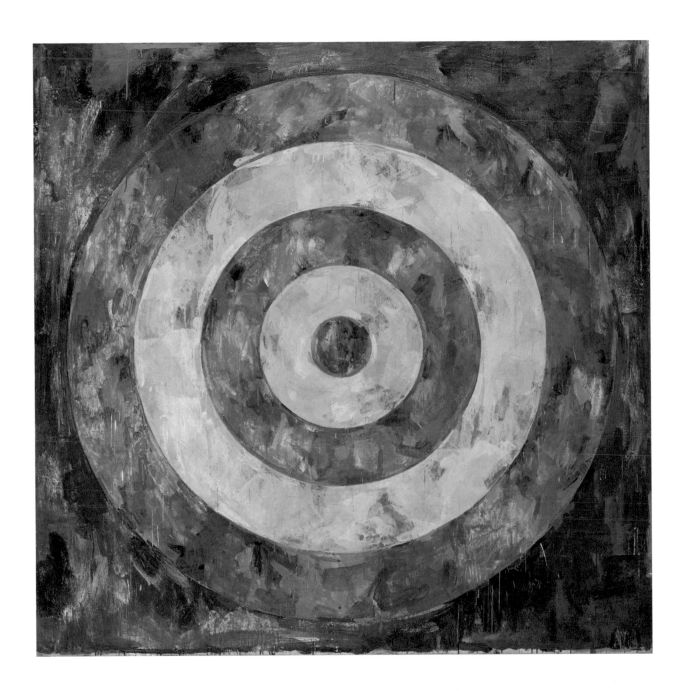

Judy Chicago

on **Agnes Pelton's**
Awakening: Memory of Father

1943. Oil on canvas, 22 × 28 in. (55.9 × 71.1 cm)
New Mexico Museum of Art, Santa Fe

Whenever I see an Agnes Pelton painting, I feel drawn to its mystery and luminosity. I always feel there is some deep symbolic meaning, but what that is isn't always clear.

Pelton was part of the Transcendental Painting Group of New Mexico, a short-lived group of painters in the 1930s and '40s who, influenced by Cubism and the Bauhaus, were primarily abstract. A peer of Georgia O'Keeffe, she was also brought to New Mexico by the great eccentric arts patron Mabel Dodge Luhan. I see a certain affinity between their work in the way they use color and form to convey an internal reality.

My reading of this painting is that it's a dreamlike scene: an abstracted landscape with both night and day present simultaneously. Stars appear in the dark sky to the left, while the small body of water is under the light sky to the right.

The form in the sky has been described as a golden trumpet, but that's not how I read it. If you look closely, underneath that shape and also on top of it is a faint texture that makes it feel like it's moving, spinning into a lighter sky. For me, that form ascending into the sky and spinning away from the landscape is a luminous symbol of death.

Agnes Pelton's father died when she was ten years old. My father died when I was thirteen, and I also dealt with his death in abstract painting. If you rotate the painting to the left so that it's vertical, the mountain turns into what looks like a silhouette. The museum reads it as her father's face, but I think that's bizarre and literal.

Women like O'Keeffe and Pelton used abstraction to convey personal meaning, as opposed to just dripping paint on canvas or making circles like Ellsworth Kelly. One of my theories is that until the advent of abstraction, women artists were not free to convey their experiences directly. Abstraction opened up the visual landscape for us to invent forms to convey our internal reality.

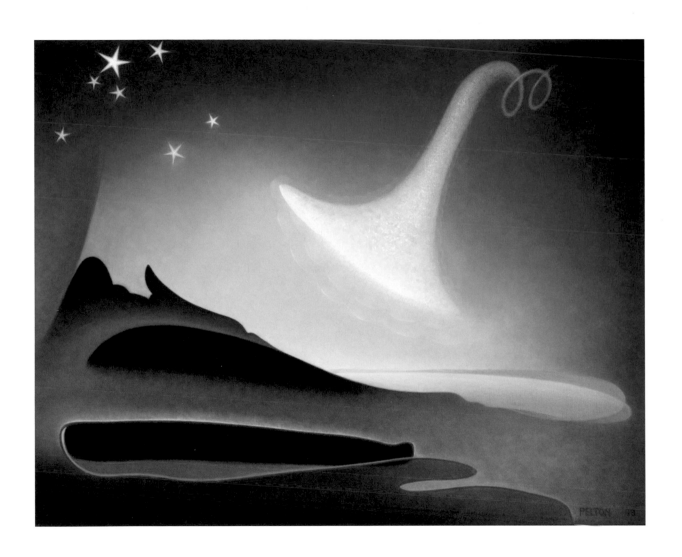

Jimmie Durham

on Ernst Barlach's *The Vision*

1912. Oak in two parts, height 46 ⁷/₁₆ in. (118 cm)
National Gallery, Berlin

You don't see very much art that tries to deal with the interior life of a human. *The Vision* is a reclining figure made out of wood, with her dream lying on top. The dream is much larger than the dreamer, almost lifesize.

I often dream that I can float in the air, and I think that's what's happening here. The hair in the dream is short but flowing backward as though pressed by the wind. That someone would try to show airy movement of a human figure floating through a piece of very heavy wood is beautifully complex and charming to me.

The wood is oak, and I can tell exactly what tools he used. He used a big mallet and a kind of curved chisel called a gouge, which lets you do the basic work very quickly and exactly. There are other tools to do more detailed work. Then you smooth the wood as much as you want with flatter blades or with sandpaper, or my father always used broken glass because he didn't have any sandpaper.

Most people who sculpt in wood tend to be sentimental in one way or another, even if they're making blocks of wood spread on the floor like Carl Andre. That's not true of stonework or metalwork. Ironwork always says: I'm a big strong piece of iron. So what I liked about this is that the sculptor treated wood as though it really is wood, but with no emotion, no silliness, no kitschiness, no nonsense.

For many years, I've been wanting to copy this sculpture in a sort of installation—a sculpture with quite a bit of wood carving but many other things also. My idea is to make a figurative, but very unrealistic, statue of Sigmund Freud sitting in a chair and then next to him is his patient, with the patient's id floating above him like the dream in the Barlach. Except that here, you will see that the id belongs to Freud as much as to his patient.

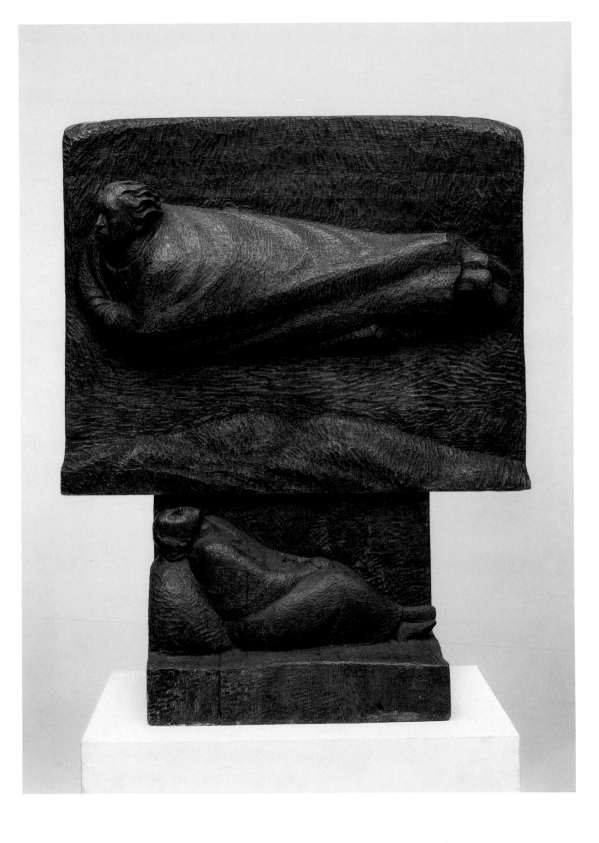

Mikala Dwyer

on Percy and Ella Grainger's
Toweling Tunic

Circa 1934. Machine- and hand-sewn using manufactured Australian (Dri-Glo) towels
Grainger Museum, University of Melbourne

Percy Grainger was this brilliant, egocentric, eccentric composer who opened a museum about his life and work in Melbourne in 1938. What's fascinating about this museum is that it bares everything. It has some of his Free Music machines, including the very weird Kangaroo Pouch Tone Tool that he invented, like crude precursors to synthesizers that were attempts to make music independent or free of the human hand. It has his extraordinary collection of whips, some of which he made himself out of conductors' batons for his own sadomasochistic practice. And it has these toweling clothes that he and his wife Ella made by sewing together beach towels. They are the weirdest things.

The tunic that I like the most is very simple: two colorful yellow and orange towels in a sort of geometric hard-edge pattern were sewn together and worn with a leather-studded belt. The tunic is really odd and inventive and looks quite cultish in some ways.

From what I've read, Percy Grainger was a health nut who felt that clothes were boring and wanted something free and comfortable. He made toweling underwear as well, and a sports bra for a running companion. I think all of his work has this proximity to the body—to pleasure or pain. Some of the other outfits are much more detailed. There's one that looks like some kind of Maori dress, like he's riffing on something he saw during his travels in New Zealand.

I love how he took the beach towels, something everybody in Australia knows, and made it into this outfit. I'm surprised fashion designers today haven't picked up on it. He does something similar in his music, turning humble folk songs into grand operatic concert pieces.

When I look at his work, it all makes sense together—I don't really separate his whips from his towels from the music. I have a big, soupy practice, too, and I find it really hard to say where one thing finishes and the next begins. Whether I'm doing performance or sculpture or teaching or making weird jewelry for the wall, it's all one piece for me.

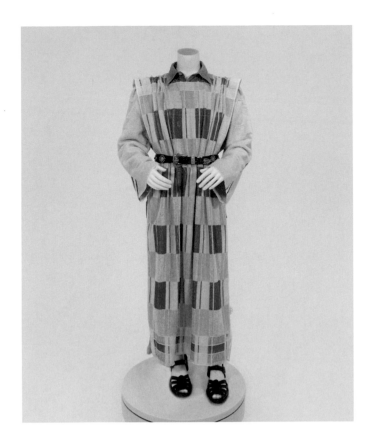

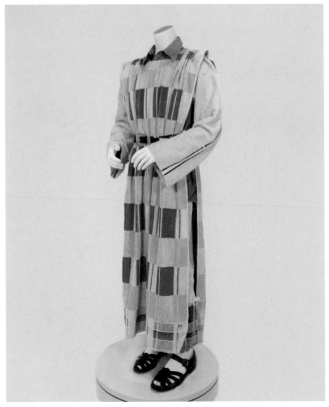

Teresita Fernández

on Wifredo Lam's *The Jungle*

1943. Gouache on paper mounted on canvas, 94 ¼ × 90 ½ in. (239.4 × 229.9 cm)

The Museum of Modern Art, New York

As a child of Cuban exiles, I grew up in Miami in the '70s, and Wifredo Lam was the first famous artist that I learned about. Miami didn't really have any art museums then, but many Cubans had books about Lam or original small paintings or signed prints in their homes, at a time when his work was not given much credit by the art world at large. I knew about Lam long before I learned about Picasso. It was only much later that I realized how important this was in my formation as an artist.

The painting functions like camouflage, where images are hiding in plain sight. We are used to thinking of the conventions of figure and landscape as distinct from one another, but Lam creates this kind of visual knot, twisting everything together. You can't tell where the sugarcane stalks end and the legs begin.

Lam painted this particular work in 1943, two years after returning to Cuba after having spent eighteen years in Europe. I think this return to the specificity of the island and his own layered cultural and racial identity is crucial to understanding the painting. His mother was Afro-Cuban and his father was Chinese. So instead of seeing Lam through European Surrealism, I tend to look at the painting through a Cuban lens. I see it in relation to the syncretism of Afro-Cuban religion with its overlapping of Yoruba orishas and Catholic saints, figures always morphing into one another.

Many of the figures in *The Jungle* have crescent-shaped African masks, and some of the legs appear to have shackles—Lam is clearly addressing the history of slavery in colonial Cuba. But instead of offering a single narrative, he has created what he has called a hallucination or a psychic state, turning the sugarcane plantations of Cuba into a sort of jungle.

The painting is also a really important example of how art history has omitted people of color from its narrative. As late as the 1980s, this painting was displayed in the hallway leading to the coatcheck room at MoMA rather than in the main galleries. Given that the painting formally creates a kind of camouflage, it is ironic that until quite recently, Lam himself was deliberately erased from visibility within the museum—one erasure on top of another.

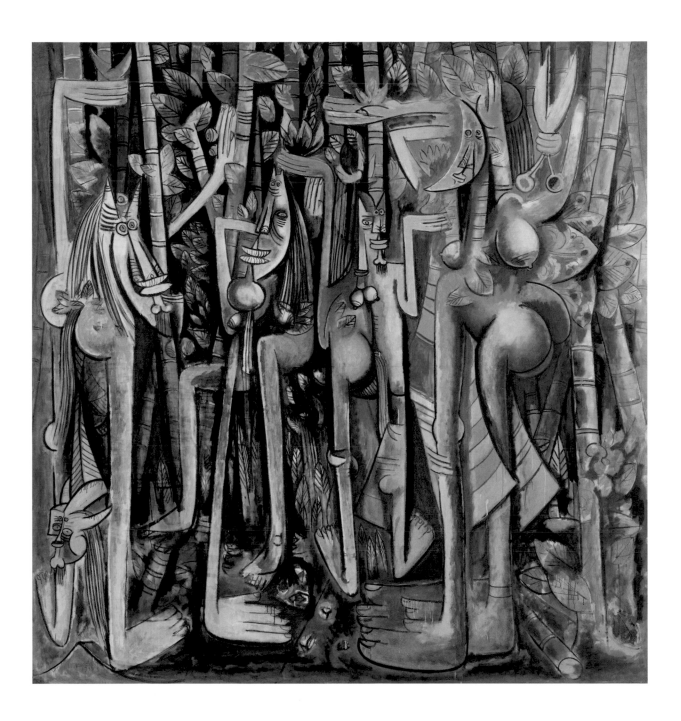

Lungiswa Gqunta

on Liza Lou's *The Waves*

2013–17. Glass beads and nylon thread, 1,182 woven cloths,
each 13 ⅜ × 14 ⁹⁄₁₆ in. (34 × 37 cm)
Zeitz Museum of Contemporary Art Africa, Cape Town

Part of what I love about this work is the deception. When I first saw it, from outside the room, I thought it was made out of floor tiling or sheets of paper, like wallpaper covering the walls. But when you look closer, you can see each sheet is very different, with tones of cream, light brown, light gray. Each panel is made completely out of glass beads.

I'm usually not a fan of beads, but I loved the way the artist used them here, so simply. I don't see waves, which is her title, but I do get a feeling of calmness, vastness, and stillness. What adds more weight for me is how the work reflects an understanding of women's labor. For years the artist has been working with a large group of women in Durban, where she has a studio, creating opportunities for women who do beading to find that kind of work. Sometimes beading is like knitting, a very calming, meditative action, but it also requires a lot of concentration and is challenging physically and mentally. You have to stay really present. It can be incredibly time-consuming.

I don't bead myself. But being a Xhosa woman, we have ceremonies that involve receiving beaded necklaces, so for me it's very much connected to ritual, tradition, and ancestry. You can watch the women making the thread in front of you from the clear lining inside a goat—it's the most amazing thing ever.

Of course with *The Waves*, I'm also suspicious: why is this white woman coming to work with black women in Africa? And how does the fact that she collaborates with the Durban women change the narrative when people write about her work? If she employed a group of white students, would they be part of the narrative? I don't think so.

I approach everything from a critical perspective, so I wouldn't say I'm 100 percent sold on this work. But I also appreciate the fact that Lou is not just coming in and out and profiting off of work made by other people. She has made a big commitment to a community. And I think *The Waves* shows her acknowledging and celebrating the labor of beading.

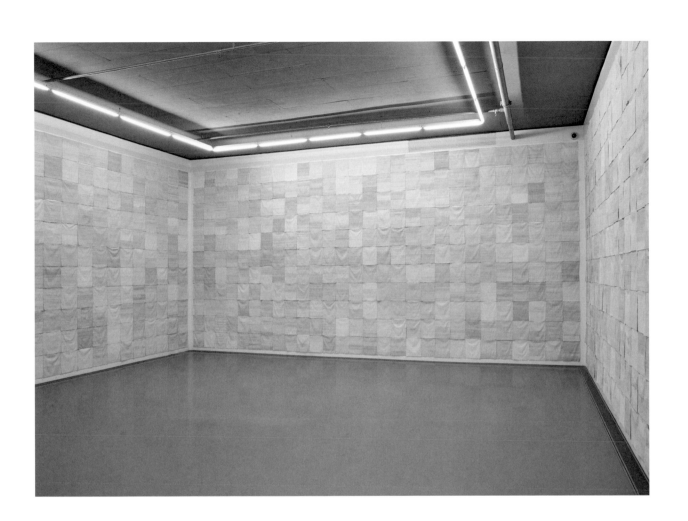

Lynn Hershman Leeson

on Amedeo Modigliani's
Pierre-Édouard Baranowski

Circa 1918. Oil on hardboard, 24 13/16 × 18 ½ in. (63.1 × 47 cm) with extensions
Fine Arts Museums of San Francisco / de Young Museum

We can see this now as a typical Modigliani, a very elegant portrait of a Polish painter who lived in Paris. I'm struck by his blue eyes, which look both vacant and full. They look like they're done in chroma key, the video editing technique where you can switch out the blue and insert any color or image you'd like.

But to me what's really interesting is how the history of technology shapes our view of the painting. It was given to the museum in 1981 by a woman who lived in the Bay Area, but its authenticity was presumed for nearly thirty years to be questionable—because they didn't know its ownership history, because it's on cardboard instead of canvas, because there are so many fakes on the market, and because it was not in the artist's catalogues raisonnés, the supposedly complete publications of his work. It was put into storage.

Then, in 2011, the donor's nephew contacted the museum in an effort to clear his aunt's name, insisting on further examination. By this point, the scientific techniques were much more sophisticated. So the museum's head paintings conservator, Elise Effmann Clifford, brought the work to what used to be known as the Stanford Linear Particle Accelerator, where the cyclotron that did particle crushing can now X-ray the painting down to the tiniest molecule, what's called macro X-ray fluorescence scanning.

They found out the painting was made in the year it should be and made of what it should be. And then they traced its ownership provenance back to the year it was made. So the museum now had evidence it's not a fake, with outside experts who agreed, and put the painting back on view.

I recently did an interview with Elizabeth Blackburn, who won a Nobel Prize for discovering the telomere, the part of DNA that affects aging. She was able to identify it because advances in the microscope lens allowed her to see it finally.

Here, too, technology is embedded in an object's identity. Once the Modigliani went through this process of being authenticated through the latest technology, the technology became part of how it's seen—part of its history, its future, and its value. It's almost like the painting was co-authored by the technology that has allowed us to identify it.

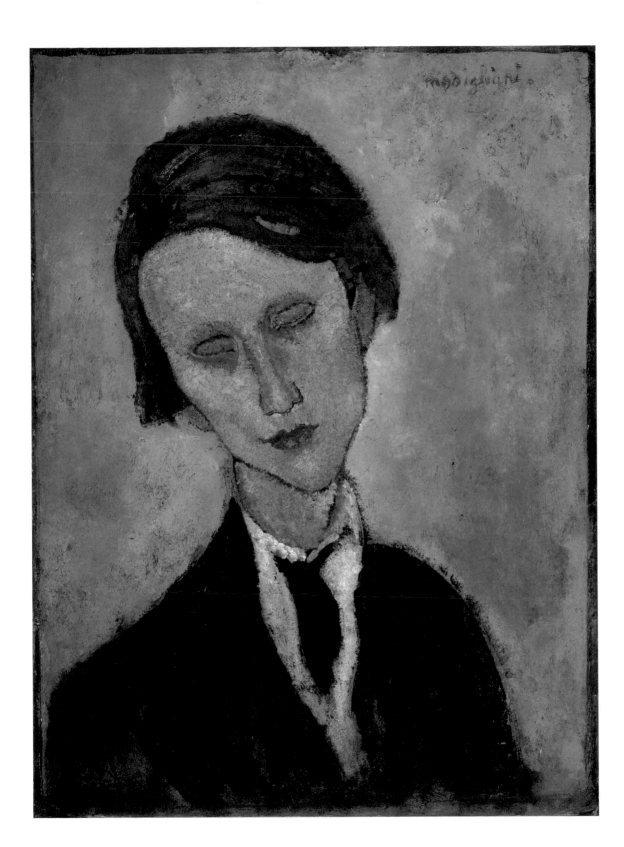

Roger Hiorns

on the Diego Velázquez workshop's
Prince Baltasar Carlos in Black and Silver

Circa 1640. Oil on canvas, 60 ⅝ × 42 ⅝ in. (154 × 108.3 cm)
The Wallace Collection, London

I'm fascinated by how time affects the substance of paintings as well as the subject matter. This is a very simple painting by Velázquez or probably his studio. The young Prince Baltasar is wearing a sash from the Order of the Golden Fleece—a European knighthood, a Belgian order established in the early 1400s. And perhaps the significance of the painting is to tie the Order of the Golden Fleece to the prince himself, showing his link to a lineage and status as a carrier of rare privilege into the future. It places him very firmly in the demands of class and royalty.

The first thing you notice when you see this painting at The Wallace Collection is that the paint itself has faded, the color saturation has disappeared into tobacco hues and old-varnish yellows and flat grays. There's a fading of the pinks and flesh tones: a near-total failure of the pigment. You can also see the mapping of craquelure and the separation of the dried paint from the surface of the canvas.

I find it interesting that this painting was once owned and restored by Joshua Reynolds, an enthusiastically experimental painter. He bought it in the 1770s, about 130 years after it was painted, and went about restoring it with his own cabinet of materials and techniques. Only there were issues with his techniques, as he was apparently painting on surfaces before the primer fully dried. His painting of John the Baptist as a young boy, on the same wall at the Wallace, has the same sort of yellowing and spoiled patina. So here you have the curious circumstance of the young painter, driven by fascination, respect, and experimentation, adulterating work by an Old Master, now thought to be by Velázquez's assistants.

The aging of the Baltasar painting also creates an accidental politics, as the vision of the prince is fading, turning into a pallid, ghostly apparition. The slow-fading prince seems to reflect the decline in the aristocracy's command and wealth—the fading of all princes, dukes, and marquesses. That slow loosening of historic authority, as we race toward a much different society, makes the experience of a visit to the Wallace such a sobering few hours.

In the closed world of art, painting has a unique position. Its responsibility is to represent a stable economy. Painted surfaces are the powerhouses of the financial world. A painting is a promise, like a check or a dollar bill. Perhaps there's something important to us all in seeing the failure of that transaction.

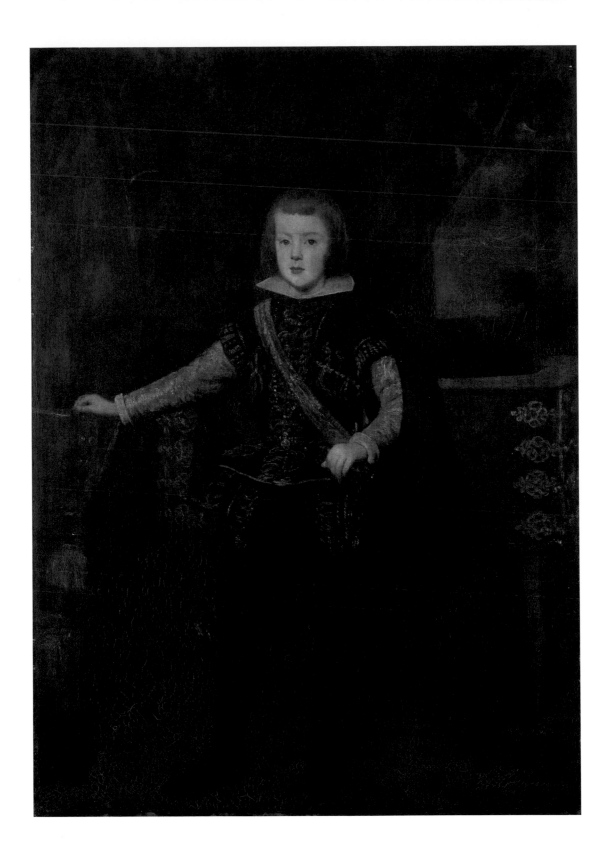

David Hockney

on Edgar Degas'

The Rape of the Sabines (after Nicolas Poussin)

Circa 1861–62. Oil on canvas, 59 ⅛ × 81 ½ in. (150.2 × 207 cm)

Norton Simon Museum, Pasadena

By the time I went to art school in the '50s, we no longer had the copying tradition that was so important going back to the Old Masters. Think about Rembrandt, who had his students copy his paintings. We had something called "transcription," but it wasn't nearly as hard—it means you look at something and make some bold strokes. You don't have to paint the eyes.

When I first saw this painting at the Norton Simon in the 1980s, not long after he bought it, I was just astonished by its accuracy. It's a copy of Poussin's *The Rape of the Sabines* that Degas made at the Louvre when he was about twenty-seven. You can imagine it was a time in the nineteenth century when there weren't that many people at the Louvre, nothing like the crowds today. It's a very good copy, and he must have learned an awful lot copying this painting. It's a shame, in a way, the Louvre didn't buy it.

The mythology is that this event took place right after the founding of Rome. Led by Romulus, soldiers were seizing women from the Sabines, their neighbors, to start Rome. The painting is challenging because of the figures, men and women, all packed together: the figures and their shadows are quite complex. You know, European art is the only art to have shadows. Japanese art, Chinese art, Persian art, Indian art, historically they don't have shadows. Their paintings give the feeling of moving through a landscape, so they don't need shadows marking a specific time.

Poussin built little models, like theatrical stage sets, before making his paintings. But I don't know how Degas copied this composition so exactly, or whether he used a photograph to help draw it out at the start.

Around the time we were doing all the optics research for my book *Secret Knowledge*, we made a transparency of the Degas version to overlay on top of a printout of the Poussin. We fit the two together, and you could see that Degas got all of the negative spaces in the composition exactly right. Every time you moved the transparency over just a little, the next bit lined up perfectly, so I got the sense he might have moved his easel at the end of each day.

It makes me think I did miss out by never copying a painting myself. It's not too late for me to copy a painting, but I would say it's too late for me to benefit from it.

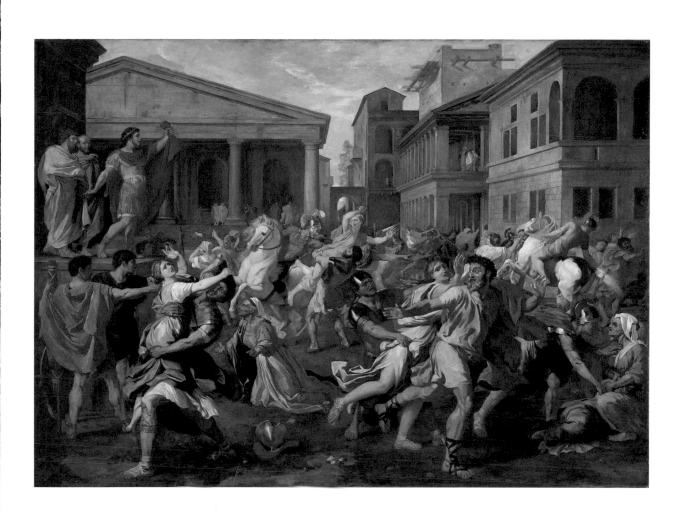

Candida Höfer

on Roy Lichtenstein's
Still Life with Pitcher and Apple

1972. Oil and Magna on canvas, 60 × 45 in. (152.4 × 114.3 cm)
Museum Ludwig, Cologne

This image has fascinated me for a long time. It makes you think of the great Picasso and Cézanne still lifes with pitchers, but this composition is even simpler: one pitcher, one piece of fruit, and the curtain and picture in the background are pretty much cropped out.

The painting is not monumental but big. The apple, for example, is slightly larger than life. And the colors are so strong: I think the most brilliant thing is the yellow table in its contrast with the red apple. It's this strong, matter-of-fact, contemporary treatment of such a classic subject; it seems Lichtenstein is playing with art history rather than just referring to it.

I first saw the work several decades ago when it was still owned by Irene and Peter Ludwig, who had a great collection of Pop Art and gave Cologne so much material the city opened a museum in their name. Then, in 2011, I saw the painting in the Ludwigs' home, which I was photographing for the museum after Irene passed away. At this point, the painting was given to the museum and shown in a typical museum setting against a white wall together with two other paintings, all keeping their distance from each other.

In the Ludwigs' home, the painting's environment was much more remarkable. It hung in their bedroom with one porcelain plate mounted on the wall above it and other plates hanging to the left and to the right. Then under the painting was a small wood dresser with an actual ceramic pitcher and platter on top. So they made their own still life under the still life.

I like the painting in both settings. There was a newness or freshness that struck me when I first saw it, and I still find it beautiful in a strange way today.

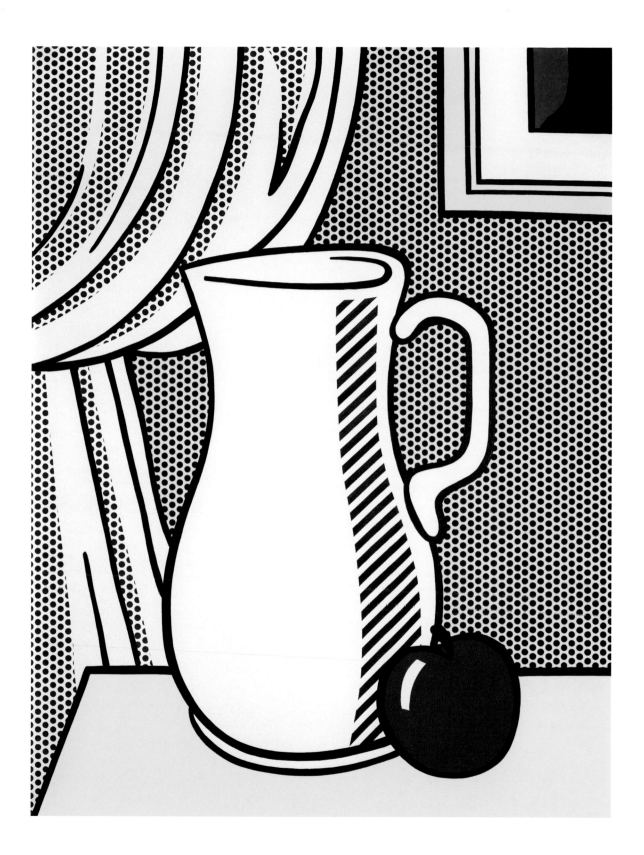

Gary Hume

on **Paul Cézanne's**

An Old Woman with a Rosary

Circa 1895–96. Oil on canvas, 31¾ × 25¾ in. (80.6 × 65.5 cm)
National Gallery, London

This is the painting that made me go to art school and made me want to paint. It's not my favorite Cézanne portrait today; it's so cumbersome in places. But it drove me mad when I first looked at it.

Over the woman's left shoulder is a great big swathe of dark blue paint that extends down from her nightcap and has been put on the canvas quite brutally. I kept looking and looking at it and couldn't understand it, and then I read on the wall text that she was probably Cézanne's house-maid and before that a nun who had lost her faith. So I suddenly saw this shape is not a piece of clothing, and it's not part of the room. This woman is bent with this weight of spiritual grief. I went from wondering what is that shape to seeing the metaphorical quality of making a mark, how it can stand for something about the character's experience.

It did something I hadn't recognized as a possibility before in painting, and I thought maybe I would like to do that. I was twenty and hadn't even started drawing at the time. I was making training films for a life insurance company and had just been sacked. After I saw this painting, I went off and worked as a life model at the Working Men's College so I could take drawing classes for free. It's amazing how a little moment can make such a transformation in your life.

I still go back to the painting sometimes. I don't have any religious feeling whatsoever, but I'm interested in the emotions that weigh us down and the fact that we have to carry on. She's not one of those wonderful bourgeois ladies who can sit down and relax. Whatever her internal life, she has to go on about her day. She has to work. Just look at her fists. Those are laborer's hands that will clean a chamber pot in a moment.

I get from her some of the same things I get from the cave drawings at Lascaux: there we were and here we are. One of the wonderful things that art can do is mirror ourselves back to ourselves. So here is this entire stranger to me from over a hundred years ago who I can still recognize because we're human, and that gives us the opportunity to be humane.

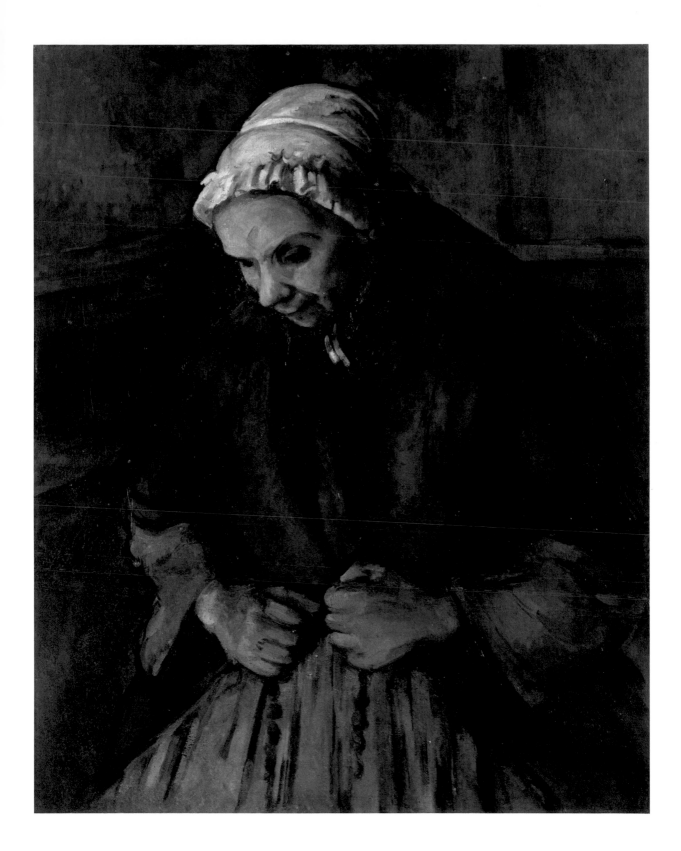

William Kentridge

on Antoine Bourdelle's
Large Sappho

1887 (cast 1925). Bronze, 82 ¼ × 40 ¹⁵⁄₁₆ × 38 ⁹⁄₁₆ in. (209 × 104 × 98 cm)
Johannesburg Art Gallery

When I was growing up, this sculpture gave me a sense of the power that art could have, both in terms of scale and my immediate attraction to it. I didn't know it was supposed to be the poet Sappho then—I thought of it as "A Woman with a Harp." Actually, I thought of it as "My Woman with a Big Toe."

It's a large bronze sculpture, larger than life, of a woman with her elbow resting on the soundboard of a harp. What held me, the compelling detail that Roland Barthes described as the punctum of a photograph, is the toe: her right foot is flexed and the big toe is pointed upward. There's something about the tension of this toe, embodying a kind of extraordinary power.

The size of the sculpture meant that her knee and head and breasts were all out of reach, especially for a child. But the toe was so close. There was, I think, something erotic in that toe, even for a six-year-old, but quite what—I would have to speak to my analyst to find that out.

The sculpture sits somewhere between the sculpture of Rodin—Bourdelle was one of his assistants—and early Cubism. You can see Rodin in the modeling and half-twist of the figure. She's not quite a *Thinker*, as she hasn't swung all the way to place one elbow on a knee, which looks correct in the sculpture but is actually extremely uncomfortable. But her torso is turned. Also, she is an immensely strong and muscular woman, and the hands and forearms are fantastic in their power. This is not a delicate, Renaissance-thin wrist. It's a wrist that comes out of Rodin or even Michelangelo. If you take away the dress, it could certainly be a man's arms and wrists.

Then there are echoes of Cubism in the angularity of the lyre and its simplification of shape and form. Bourdelle is flattening the curved surfaces of the instrument, breaking down the world into a series of facets.

The sculpture I've been doing recently has something of these angularities. I wouldn't put too much emphasis on it, but there is some common language. I'm certain that one's head is filled and formed by these early encounters with particular works of art.

50

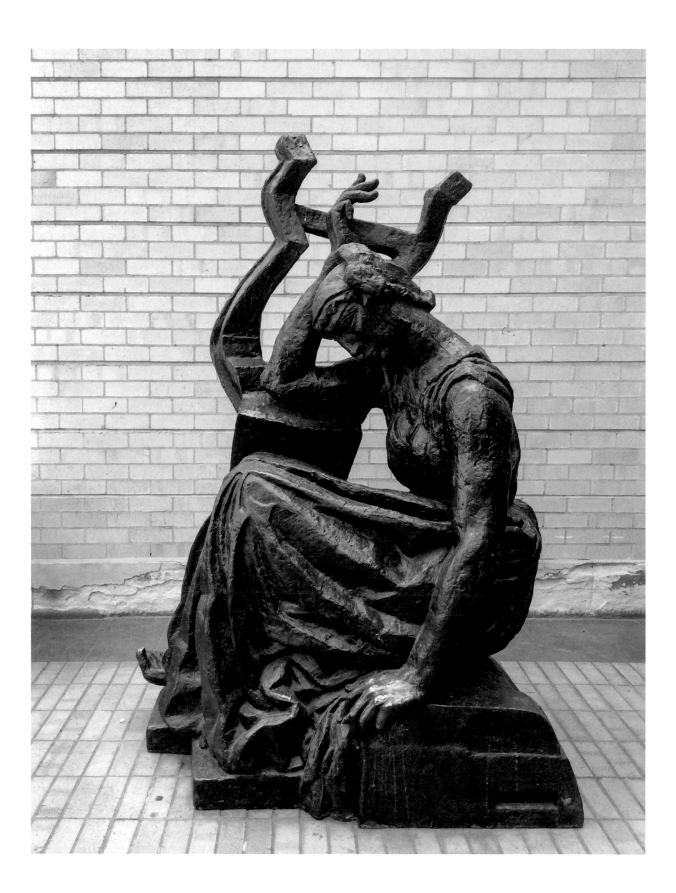

Suzanne Lacy

on **Andrea Bowers'**

Nonviolent Civil Disobedience Drawing—Elvira Arellano
in Sanctuary at Adalberto United Methodist Church
in Chicago as Protest Against Deportation

2007. Colored pencil on paper, 30 × 22 ¼ in. (76.2 × 56.5 cm)

Hammer Museum, Los Angeles

Elvira Arellano is an immigrant from Mexico whose son, a U.S. citizen, was born in this country. After years here, she faced deportation because she was not documented and went into sanctuary at the Adalberto United Methodist Church in Chicago. Andrea went there in 2007 to do a project—video and drawings—around Elvira, who became a symbol of one of the most contentious debates in the United States: immigration reform.

I find this small, colored pencil drawing of Elvira very seductive, a tiny image on a large sheet of paper with all this extra white space that pulls us in. It isn't heavy, it isn't black, it isn't a Francis Bacon. I see all the white space as a way of focusing our attention, a demand that we pay attention to the woman who is about to be separated from her son and that we recognize her grief, her pain, the injustice. The blank space on the paper surrounding Elvira is the space of our imagination.

Another thing that strikes me is how incredibly labor-intensive the pencil drawing is. A single drawing can take Andrea several weeks, with hours and hours of meticulously gridding the paper and peering through a magnifying glass. You wonder: Why doesn't she just take a photograph? Why the labor to represent Elvira? There is something important politically as well as aesthetically about the artist's labor—the time she devotes to her subject.

And the drawing is just gorgeous because of the intensity of her work. Bowers uses her seductive craft to engage our eyes, hearts, and minds. I see this as an eloquent plea to pay attention and confront the realities of immigration, an issue that grows ever more alarming and heartbreaking.

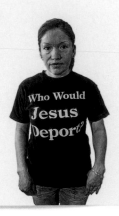

Suzy Lake

on Rebecca Belmore's
Rising to the Occasion

1987–91. Mixed media, 78 ¾ × 47 ¼ × 39 ⅜ in. (200 × 120 × 100 cm)

Art Gallery of Ontario, Toronto

I first saw *Rising to the Occasion* ten years ago and remember being quite choked up by its politics, passion, and compassion. I immediately felt the artist's struggle and resilience through its materials and juxtaposition of elements. But the sculpture is not agitprop at all. Rebecca's colonial dress is poetic and generous in the way it gives each viewer his or her own point of entry.

I had met her years earlier as a student in a mid-eighties performance class I taught at the Ontario College of Art and Design. She was smart but a bit shy. While I was aware of her performance-based photographic works, I was thrilled to experience the strength of her voice through this reappropriated Victorian garment. I not only responded to her indigenous voice—she is Anishinaabekwe—but also a strong feminist one.

Usually the dress is displayed in the middle of the room, so you can walk around it to examine its materiality and feel the presence of its body in relation to your own. From the front it seems like an elegant but aged Victorian dress made of satin and beaded velvet. But at the same time, you see two very English flowered dinner plates—the kind you can easily find at thrift stores— where the breasts would be. The plates humorously subvert the image of the traditional, proper wife serving meals to her husband. A headband with taut, inverted rope braids is suspended above the dress, suggesting to me a noose.

The backside of the dress is made from a bundle of sticks that look like a beaver dam and include monarchy souvenir trinkets and the sort of litter that beavers might use as well. These references reflect the artist's deep connection to the land and her community's hunting and trapping industry. The contrast between the bustle made of sticks and a civilized European dress opens rathers than closes discussion of her resilience and resistance to colonization.

I later learned Rebecca's story of the dress, about how the duke and duchess of York were visiting a fur-trading fort near her northwestern Ontario hometown for the purpose of meeting the indigenous community. I love a work that begins as a question: If I were to meet the duke and duchess, what would I wear? And Rebecca's answer is an empowered one.

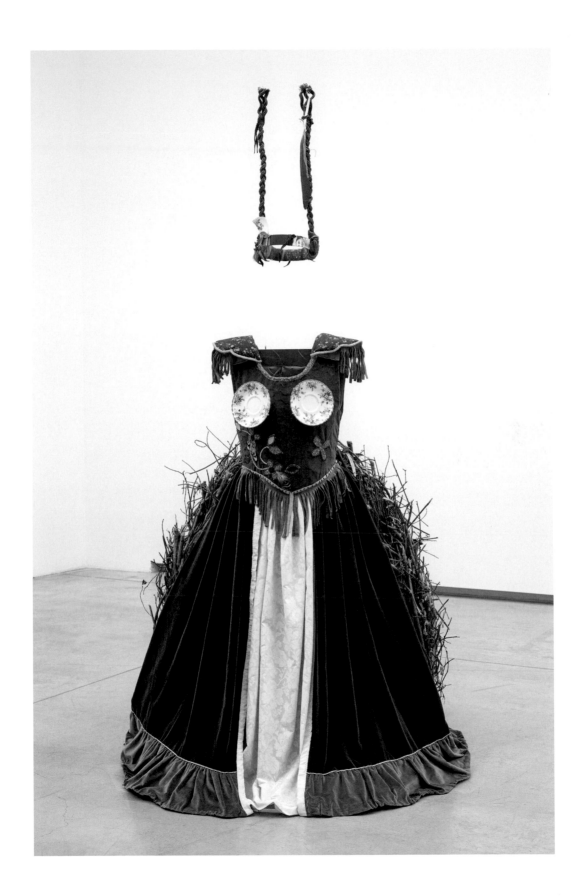

Liz Magor

on an eight-sided Tlingit box

Late 19th century. Pacific Northwest Coast. Probably yellow cedar,
5 ⅛ × 6 ¼ × 14 ⁹⁄₁₆ in. (13 × 15.9 × 37 cm)
Museum of Anthropology, University of British Columbia, Vancouver

There's nothing I love more in the world than the bentwood boxes of the West Coast people. They are so simple and beautiful, made out of a single piece of wood that is folded like paper, like origami. The artist would make a chamfer cut at each corner—a kind of angled groove that takes the bulk out of the wood, and then fold it there. The last corner is held by stitching or pegs. The bottom is a separate piece of wood and can be thicker because it doesn't have to fold.

These boxes are always made out of cedar because it's lightweight and has such a long fiber that you can fold it without it cracking. I suppose the technology of wooden boats and barrels is similarly marvelous, but the ingenious design of these boxes maintains a tension that includes the possibility of them springing back to their original plank form.

This eight-sided Tlingit box must have been especially challenging to make, with twelve corners created from a single four-foot-long plank. Eight corners fold in and four fold out. It's basically two boxes with a short channel running between them, probably fashioned for some kind of draining or separating job. It's not very big. Maybe it was used for juicing berries or collecting the liquor from clams or mussels. I don't think much about its practical implications apart from the fact that it's able to hold liquid.

More persistently, I think about its Siamese twinness, how the two boxes that make up this object are yoked together in a kind of forced interdependence. Each box is almost solo except for the fact of the channel that punctures one of its sides, allowing the contents of one to slip into the volume of the other. This soft boundary is a vexed thing: it's hard to know if it's an intrusion or an opportunity, a disability or an innovation.

Wilson Duff, a brilliant anthropologist who taught in Vancouver in the '70s, proposed that some art of the Coastal people, who didn't have written language, could be regarded as a form of visual philosophy. In addition to being practical tools or spiritual statements, these objects posit the mutability and coexistence of opposites: top and bottom, back and front, inside and outside, life and death. He saw them as puzzles of physics and philosophy, and I'm sure that his writing influenced me when I first saw this paradox of a box. It's both a practical thing and a profound thing at one and the same time.

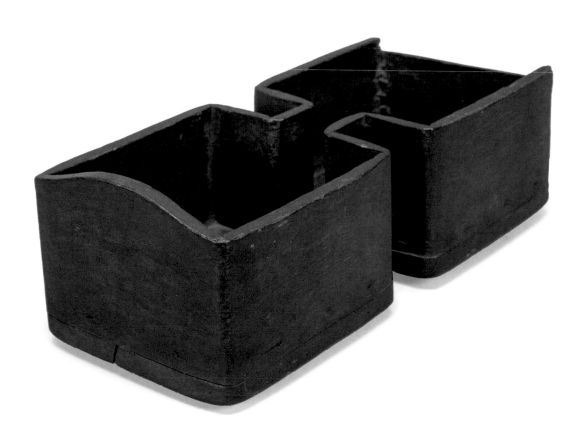

Annette Messager

on **Nicolas Poussin's**
The Massacre of the Innocents

Circa 1625. Oil on canvas, 57 ⅞ × 67 ⅜ in. (147 × 171 cm)

Condé Museum, Chantilly, France

Unfortunately, the subject of this painting feels very current to me, with all the massacres of children going on in the world today. The story here, the Massacre of the Innocents, comes from the Book of Matthew: Herod, the King of Judea, decided to kill all the babies in Bethlehem.

I think that the most important thing in the picture is the mother at the center, with her strange expression and unrealistically long arm. Her arm is not anatomically possible—it's almost as long as the sword of the soldier. She is trying to save her baby, but of course it's impossible. You can already see blood on the baby's body, and the soldier's foot is on his neck.

I'm especially interested in the woman's face. She is very white, like stone, and her expression is more a Greek mask than a face. She looks possessed. She is crazy with grief already. The soldier's expression is just the opposite: he is almost smiling; he looks pleased. Another strange element in the composition is the scene with the woman in blue. Just to her right, there's a circle. At first I thought it was an architectural column, but it's not, it's the head of the dead baby she is carrying.

By the time Poussin painted this, there were already many representations of the Massacre of the Innocents by other artists. But they always painted vast battle scenes full of people and great confusion. Here, he focuses on just four main characters, and you can see the violence done to them with these close-ups on their faces, their arms, and their legs. I think that's why this painting impressed Picasso so much when he was making *Guernica*. And Francis Bacon, who in his twenties briefly lived in Chantilly, where the Poussin is located, was clearly influenced by the face of the mother. He made these great paintings of faces where all you can see is an open mouth.

Bacon called it the most powerful scream in the history of painting. In my own work, too, I'm fascinated by this kind of cry—how the body speaks, how the arm speaks, how the face looking up to the sky speaks. For me, sadly, the subject is still current today because so many children in Syria, Libya, and other countries are being killed. The painting reminds us of the history of terrorism.

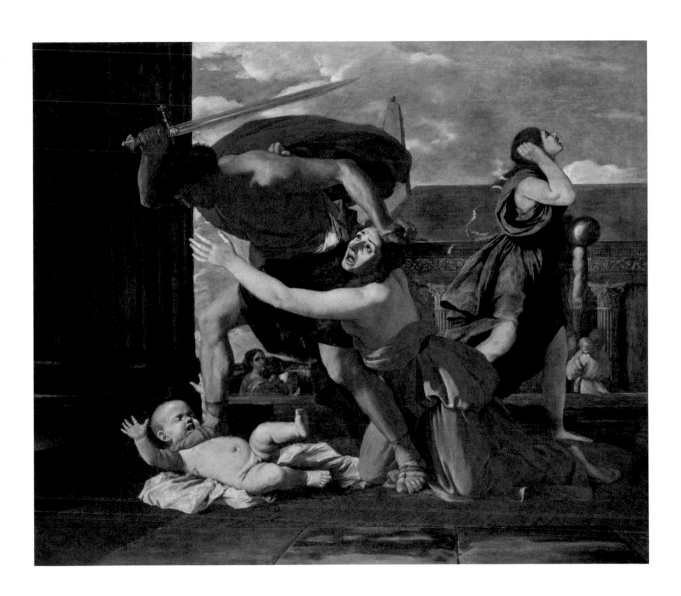

Beatriz Milhazes

on Victor Meirelles de Lima's
The First Mass in Brazil

1860. Oil on canvas, 106¼ × 140½ in. (270 × 357 cm)
National Museum of Fine Arts, Rio de Janeiro

Victor Meirelles is the best-known painter of nineteenth-century Brazil. I grew up seeing this painting in schoolbooks, not just art books but books on the country's history. As a kid, it was like an open door for my imagination: what Indians were like, what the Jesuits were like. It takes a situation that could have been very tragic and gives it this magical atmosphere.

This scene shows the first Catholic mass held in Brazil in the year 1500. A fleet of Portuguese ships was filled with explorers—Jesuits and representatives of the royal family and the army—who were heading for India but were diverted and arrived in the northeast of Brazil. They landed in what is now called Porto Seguro in the south of Bahia, where they met some natives. They decided to stay there and hold mass, as if symbolically to say it's now our land, it now belongs to us, and the priests are sanctifying the earth. You can see beach vegetation in the background, suggesting they very recently landed and remain close to the shore.

Meirelles painted the scene in the nineteenth century, three centuries after it happened. What's interesting for me is the role his imagination plays in the scene. He based the image on an important letter to King Manuel written by one of the Portuguese travelers, Pêro Vaz de Caminha, but at the same time you can see the artist's own thinking about the characters.

He rendered the rocks where the Indians are sitting and the Indians themselves a little more roughly, trying to suggest, I think, a difference between "civilized" people and "natives." But he still modeled the natives on Europeans, like the woman lying naked on the rock.

The painting is very skillful. It looks like a beautiful, peaceful moment in which the explorers—really invaders—and Indians are part of the same community.

I don't know if this encounter was really like that. I doubt it. But it does fit this complicated idea that we as Brazilians have about ourselves of not being the most aggressive people. We don't have that many wars in our history.

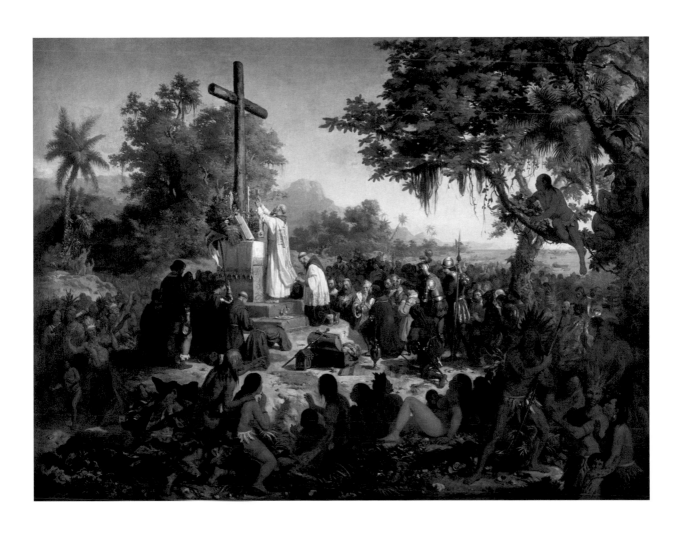

Yoshitomo Nara

on Inges Idee's *Ghost*

2010. Steelframe, fiberglass, reinforced plastic-FRP, and
2K-lacquer, height 29 ft. (8.9 m)
Towada Art Center, Towada, Japan

Ghost is located on the lawn in front of the contemporary art museum in Towada, a regional city in northern Japan that has a population of about 60,000 people. Initially I was taken aback by how enormous *Ghost* is; the sculpture rises taller than the museum buildings around it. But in spite of its size, I felt its sense of lightness and flotation. It helps that the sculpture does not have a fixed base or pedestal—*Ghost* seems to float right off the ground.

The artists behind this work, a German collective named Inges Idee, made a smaller outdoor sculpture at the museum that works in dialogue with *Ghost*. It succumbs to gravity instead of resisting it. It's called *Unknown Mass*, and it hangs off the roof of a building with public bathrooms, drooping down over the window there. Both creatures have eyes and appear to be glancing at each other.

Together these sculptures create a scene that not only deviates from the everyday norm of local people's lives but also blends joyfully with the site of the museum, which spans a full city block. I'm happy to see work like this in the region where I grew up, bringing vitality to this site. I imagine it quietly brings pleasure to the people who share space with it.

This weightless, floating feeling that the artwork inspires is not only physical. You can also read it as a form of freedom that exists in many of Inges Idee's public sculptures. They use such accessible images to draw our interest, before we try to figure out the riddles of the artwork's meaning. It's wonderful when artists adopt the attitude of imbuing art, which can be so dense, with a sense of lightness, and release it into a public space. I think of this type of art making as a gift for the community. I long for this.

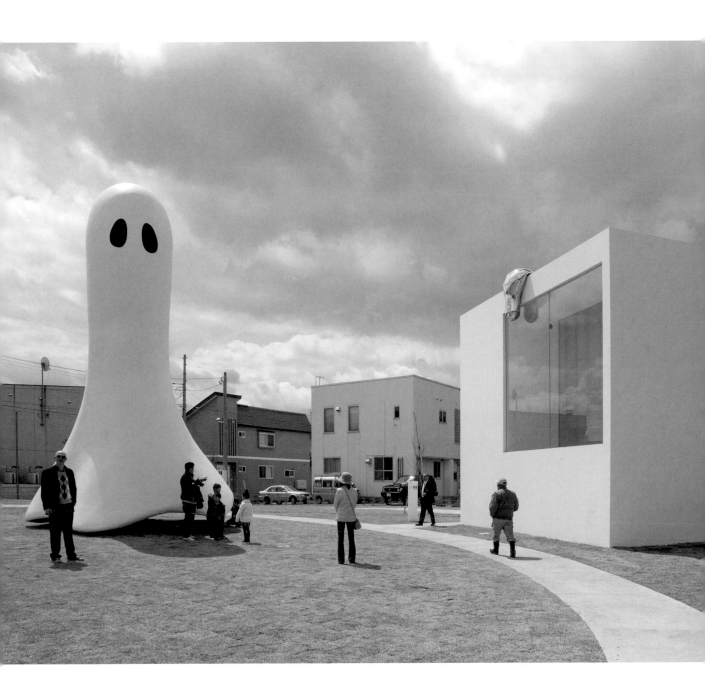

Shirin Neshat

on Alice Neel's *Andy Warhol*

1970. Oil and acrylic on linen, 60 × 40 in. (152.4 × 101.6 cm)
Whitney Museum of American Art, New York

Making a portrait of a celebrity who has been photographed or painted a million times can be very challenging. How can you go beyond the persona to capture their true character and convey something new and not redundant? How do you go beyond the constructed image to reveal the vulnerability and humanity of who they are?

Alice Neel does this so brilliantly and simply in this painting of Andy Warhol, getting under the skin of this powerful artist. She actually shows us his scars. You can see his scar from being shot by Valerie Solanis, and the medical corset he wore afterward. You see his breasts, which are exaggerated to look very feminine. I think asking him to take off his shirt was an incredible move, and I still can't believe he agreed to it.

It's hard to think of an artist who controlled his image more carefully than Warhol. He always wore a wig; he was a socialite but at the same time very antisocial, very cool. And it was devastating for him to be seen naked. So this painting really goes against type. It's the only portrait of Warhol I can recall where he lets go of all of these shields.

I also love the unfinished quality of the painting. At the bottom, his shoes are glossy and shiny, like he was dressed to go out, but as you look up, a lot of the painting looks unfinished. The light blue color behind Warhol could be the beginning of some background—you would think Neel was going to paint the whole background blue and fill in the couch, but she stopped right there. I think she was trying to capture the spirit of her subjects, and the minute she did that, she would stop. It's one of the most powerful things about this painting, how minimal and simple it is.

It's a tremendous lesson for those of us obsessed with the human portrait as a powerful vehicle for communication. For my feature film, *Looking for Oum Kulthum*, I spent six years thinking about how to make a narrative to get under the skin of this iconic singer loved by millions of people in the world. I couldn't do it in the end. Instead, I made a film about a filmmaker trying to make a portrait, a biopic, of this woman nobody could really know.

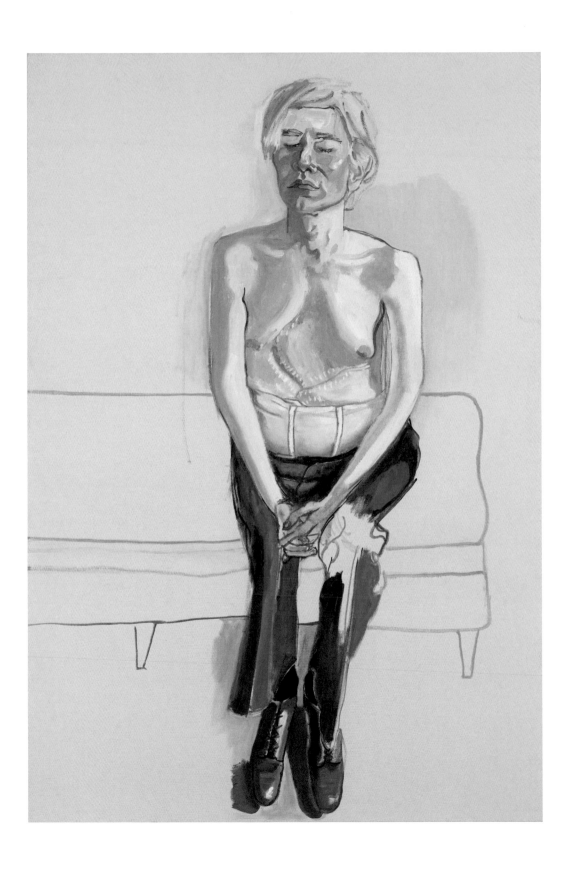

Tuan Andrew Nguyen

on a Vietnamese sculpture of Buddha

4th century. Vietnam, Kien Giang Province, Oc Eo culture. Wood, height 54 ⁵/₁₆ in. (138 cm)
Fine Arts Museum of Ho Chi Minh City

To me this object feels familiar, even recent, because it looks like it could have come out of Abstract Expressionism. It looks almost gestural, like a brushstroke that was somehow dimensionalized, given depth. But it comes from much, much earlier, from the fourth century.

It's a wood Buddha statue from the southern part of Vietnam, probably from a temple. The head is gone, arms are gone, and feet are gone. Maybe it had been buried after one of the many wars here, or during one of the monsoons that happen so often in this part of the country. But the rest of the body compares to a standing, robed Buddha. Even though the form is perforated, the corporeal element of the object is still there. You can make out the body: the torso, hips, and hints of the legs.

I'm fascinated by objects, narratives, and rituals existing in a liminal space, a space that exists in between clearly defined areas. I think this object oscillates between two different times: historical and contemporary. It also exists between abstract and figurative.

I also see this object as somewhere between being and not-being. It's almost gone and it's still there simultaneously. It seems to me a very Buddhist way of thinking: in Buddhism, there's a lot of interest in the "bardo," the state between death and rebirth.

In my work with The Propeller Group, I used to think about the tension that an object can hold, but lately I lean toward the idea of an object existing without tension but doing so in a kind of poetic space, an in-between space, where it can seamlessly be multiple things at once. It's not really a hybrid but more like a ghost, a ghost that can move between spaces and identities at will, not bound by any laws that dictate ways of being.

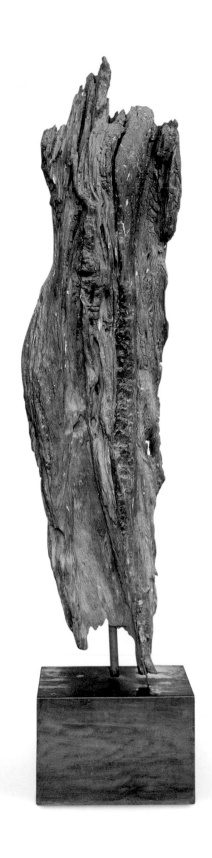

Ahmet Öğüt

on Jan Asselijn's *The Threatened Swan*

Circa 1650. Oil on canvas, 56 ¾ × 67 ⅜ in. (144 × 171 cm)
Rijksmuseum, Amsterdam

In almost all Old Masters paintings of this time, animals are either shown out in nature playing a small role in the scenery, or dead in the kitchen or butcher shop, hanging upside down. Here, the swan occupies almost the entire painting, and it's really lively and in motion. To have an animal so central is really unusual.

Then, when you look closer, you can make out three texts. Above a little dog, almost invisible in the lower left corner, it says in Dutch: "the enemy of the state." Under the swan, it says "the grand leader." And that swan is actually protecting a small egg on our right that says "Holland."

So there's a clear political allegory in the painting that first looks like an elegantly painted swan attacked by a dog. The swan is said to represent Johan de Witt, the republican leader who was assassinated in 1672. But the work was made about twenty-two years earlier, soon after the Eighty Years' War ended and the Dutch gained independence, so it's strange that the painting could have predicted his rise and fall.

I'm really interested in these metaphorical, political paintings that somehow transcend their time. Another is the 1889 painting by Franz von Stuck that I researched when working on my solo show at the Villa Stuck in Munich: *The Wild Chase* is a painting of Wotan, but the pagan god is portrayed here as a leader running toward us and leaving complete doomsday-type destruction behind. The painting was made the year Hitler was born, and it hung for a while in his office. There's a rumor that it became an inspiration for the way Hitler looked. I also think about the *New Angel* monoprint by Paul Klee, who briefly took an art class with von Stuck in Munich. Klee made it in 1920, well before World War II. In 1940, Walter Benjamin, who first owned the work, saw it as the Angel of History—flying backwards toward the future while facing the destruction left behind.

All three artworks have figures in the center flying toward or away from us. But for me, the real connection is that these museum pieces feel contemporary and they stay alive because of our debates over their meaning or because of our doubts; I think we still have a lot to learn from them.

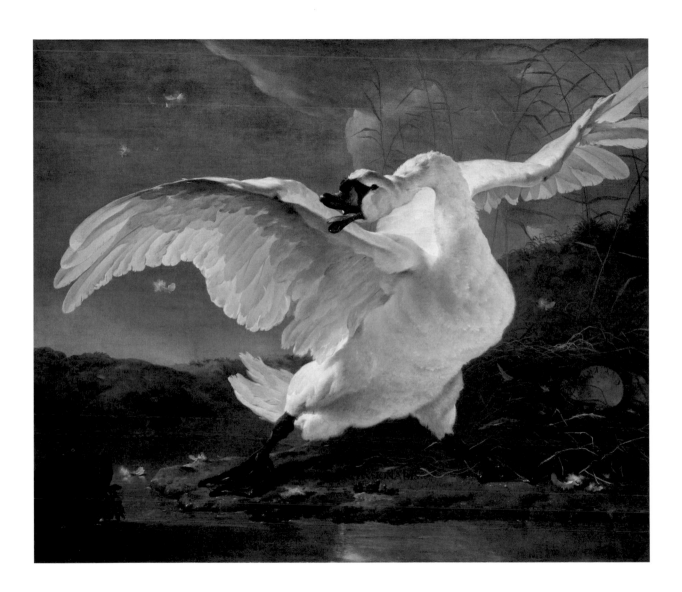

Gabriel Orozco

on the Aztec Sun Stone

1325–1521. Basalt, diameter 141 in. (358 cm)

National Museum of Anthropology, Mexico City

The Sun Stone is probably the most famous sculpture in Mexico. Its image appears everywhere, on everything from t-shirts to money, so that it has become a symbol of the country. It comes from Aztec culture and has many explanations and interpretations. It looks like a solar calendar, but some say it's more mythology than astronomy. The stone disk is very large and now hangs vertically, but it could have been used horizontally as a platform for something, maybe for sacrifice.

I see it as a work of art that feels very abstract and contemporary—not so much an instrument for marking time but an image of cosmology or a condensed diagram of the universe. The face in the center looks like a mask of a god or monster. There are circular rings with shapes that look like the points of stars or the rays of the sun. In the inner rings, a number of animals appear, like a dog, deer, and rabbit.

It's like a circular book that's telling you about life cycles and seasons. Or like a mandala, where your eyes follow the reliefs and carvings. But there's also some strange opacity that prevents you from taking it all in at once, almost like the way it's hard to see the sun directly.

I also find it fascinating that this calendar looks very modern. It's very ancient obviously, carved many centuries ago, but it looks somehow connected with modernity or contemporaneity. It looks high-tech in a way because of the amount of information engraved there, like a computer chip.

I don't remember exactly the first time I saw it, but I was young enough that I was holding my mother's hand when walking through the museum. I must have been four or five. As a kid, it's easy to be impressed by this massive stone disk with its complex, circular carvings—enough information to describe a whole civilization.

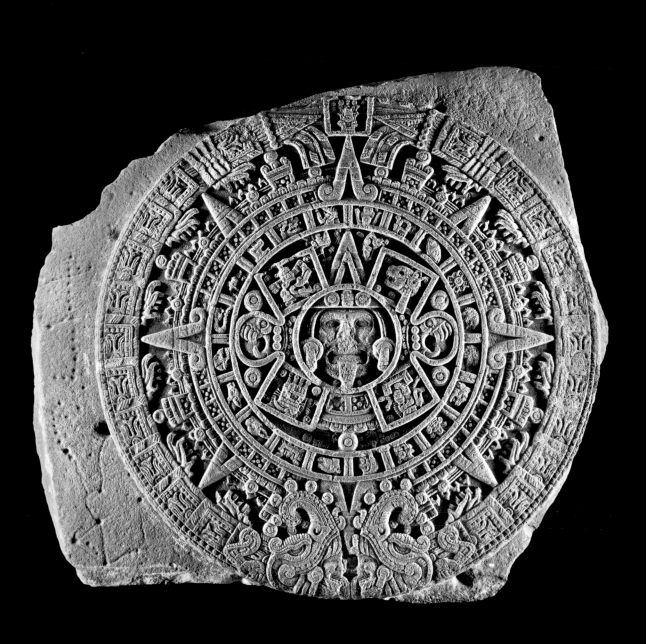

Cornelia Parker

on **Paolo Uccello's**
The Battle of San Romano

Circa 1438–40. Egg tempera with walnut oil and
linseed oil on poplar, 71⅝ × 126 in. (182 × 320 cm)
National Gallery, London

I like to pop into the National Gallery whenever I'm nearby to see a handful of paintings, and I've spent a lot of time in front of this one particularly. It's a hugely satisfying feast with plenty for the eye to do.

The scene is a historical battle between Florence and Siena, but it's not important for me to know the historical references. I'm more interested in the painting's mood, its curious formalism and its dynamism. It glows with a rich palette of colors, including reds and gold. The silver leaf of the soldiers' armor has tarnished gray over the years, as if the soldiers have been perpetually in combat.

Uccello conceived his painting of this battle as an elaborate exercise in pictorial space, using the tools of Western perspective at a relatively early stage in its history. He created rhythmic patterns with the flags and weapons that the soldiers are holding. All the lances line up diagonally on the left side of the painting, and there is a hill rearing up in the back blotting out the sky. The painting is very tapestry-like in its patterning and slightly wooden figures. It has a similar quality to paintings by the French artist Édouard Vuillard, who was inspired by the history of tapestries.

It feels uncannily ordered. In the foreground, broken lances and a fallen soldier line up in a neatly arranged pattern pointing to infinity. The trees in the background are dotted with white flowers, echoing the gold dots on the horses' livery. These are wooden horses. You can't see the sweat on their brow.

War itself is a horrible mess, disordered, disorganized; the battlefield is where well-laid plans evaporate. This painting offers a very stylized image of violence. It gives an impression that somehow this battle, at least, is following a plan.

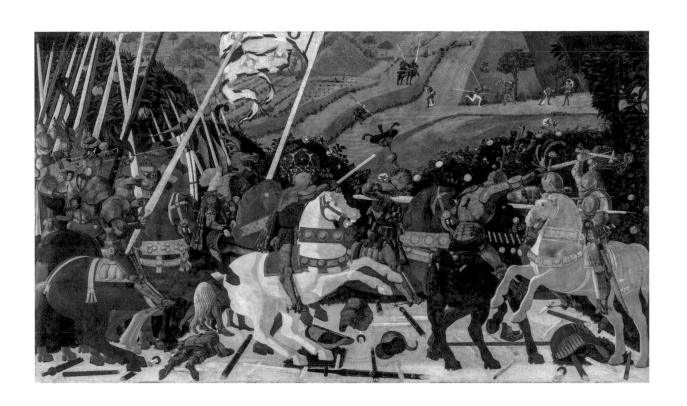

Mai-Thu Perret

on Sherrie Levine's *Krazy Kat: 5*

1988. Casein on wood, 18 ½ × 15 ¾ in. (47 × 40 cm)
MAMCO–Museum of Modern and Contemporary Art, Geneva

I love this version of Krazy Kat because it's the only time I've seen Sherrie Levine using an image from popular culture. She's famous for appropriating very canonical images by artists like Man Ray or Walker Evans: she lifts entire images from previous moments in art history and replicates them exactly as is but claims the results as her own work. With a gesture of blatant reproduction, she opens this very eerie gap between authorship and authority. She asks: What is an artist? What is an image and who owns it?

Using Krazy Kat seems especially smart because it's also a messed-up story where generation or creation doesn't happen. George Herriman has set up this insanely repetitive and hilarious love story of a cat in love with a mouse, who hates the cat and keeps throwing bricks at it, while a dog who is also a police officer, the representative of the law, falls in love with the cat. The comic strip ran in the Hearst newspapers for decades, and the story would keep repeating and repeating, with small variations. With this love triangle between cat and mouse and dog, there is no possibility for a child to be born. The characters are mismatched; they are different species. On top of this, Krazy Kat is both male and female, sometimes a "he" and sometimes a "she," a magical, genderless creature.

I find that fascinating in relation to Sherrie Levine's work because her critique of authorship also has to do with issues of gender. I think she's creating a short circuit by taking someone else's artwork as her own and refusing to create. She refuses to make something new, rejecting the very male myth of a creative genius engendering original art.

Her work does violence to all of these received ideas about what creativity looks like. And if you just read about it, it sounds very theoretical and cold. But I find it very moving. My feeling is that she only appropriates things that she adores. I think there's a tension between her love of Krazy Kat and this aggressive or even cannibalistic gesture of appropriation. I find the work transgressive in the most sly, silently angry way.

Bernard Piffaretti

on Antoine Watteau's
Pierrot

Circa 1718–19. Oil on canvas, 72 ¼ × 58 ½ in. (184 × 149 cm)
Louvre Museum, Paris

The Louvre painting is a fragment, a piece from a larger composition that hung at a café théâtre in Paris in the eighteenth century. I used to talk about it with Jean Fournier, who had a very important contemporary art gallery in Paris showing Joan Mitchell and Sam Francis. His gallery was located on rue Quincampoix, the same small street where this café théâtre was situated. He loved this painting too.

Above all, I see this painting as an object with a real, physical presence. It's true of any painting, but I think Watteau reinforces this sense by positioning his central subject, the servant Pierrot, to face us directly. Also, the canvas is bigger than most Watteau paintings, so Pierrot has the same dimensions as the viewer, making our relationship to the painting more immediate.

The figure of Pierrot has a verticality that we associate with modernism and artists like Mondrian, Manet, or Barnett Newman with his zippers. This figure is like a cliché for me, and the central mark in my painting is also an echo of this device.

But we know from the cropping marks on the picture that the canvas was originally even larger, before it was removed from the old café théâtre, cut down, and placed on a smaller frame. If you look at the painting in this manner, then Pierrot is no longer the real center of it.

Sure enough, all the action in the painting takes place very efficiently at the bottom with the four characters from the commedia dell'arte. There's such a contrast between Pierrot, who is static and wears all white, and these other characters, who are dynamic and wear colorful clothing. I think this visual opposition is a contrast that you can find throughout the history of painting between colors that are flat or controlled and those that are more gestural or dynamic. Whether you think about a painting from the sixteenth century or Abstract Expressionism, you can always see how the inscription of two different gestures is what holds the eye.

I also find the eye of the donkey transfixing; it almost works like a hole. To be present in front of an artwork means losing yourself. It makes me think of Mark Rothko, who basically said: I paint large in order to be intimate, to let you enter the painting.

Ana Prvački

on Gustave Courbet's
Grotto of Sarrazine near Nans-sous-Sainte-Anne

Circa 1864. Oil on canvas, 19 ¾ × 23 ⅝ in. (50.2 × 60 cm)

The Getty Museum, Los Angeles

To be honest, the first time I saw this painting at the Getty, I walked past it. Then when I saw it was Courbet, I went back and was just stunned.

It seems like a very inoffensive landscape, but two years later Courbet painted *The Origin of the World*, depicting the genitals and abdomen of a naked woman with her legs spread apart. Of course, it was extremely controversial when he first made it, and there's this incredible history of who owned it: the Turkish-Egyptian diplomat Khalil Bey and then Jacques Lacan, who kept it behind a wood panel painted by Surrealist André Masson. Of all the paintings in the world, the great psychoanalyst chose to buy this.

To me this painting of a grotto feels like a sketch for *The Origin of the World*—they're formally and conceptually so similar. Here we have an entrance into a cave: not a little dirt path, but straight, industrial, what almost looks like a mining trail. There's something ominous about the tracks: I get a sense of the exploitation of resources and the earth. But I also see this entrance as an opening into a body. If it were another painter, maybe I would believe he was doing a realistic geological study. But not Courbet, and not so close to *The Origin of the World*. I think the positions of the openings in the two paintings are very similar and also the dark coloring—these mossy and lush colors. There's an interesting softness to this painting too.

I've been collecting Japanese erotica called *shunga* prints for six years now, and I'm interested in their influence on Western painters. There's one *shunga* print I own that I first saw at the British Museum and became obsessed with, from *Eight Views of Omi* by Utagawa Kuniyoshi. It was made in 1833, over thirty years before *The Origin of the World*, and it also transforms the female body into a landscape. I'm very curious if Courbet ever saw it.

Pipilotti Rist

on a Chola Dynasty statue of Shiva Nataraja

12th century. India, Tamil Nadu, Tanjavur District
Bronze, 32 7/16 × 30 5/16 in. (82.4 × 77 cm)
Museum Rietberg, Zurich

One reason I like the Museum Rietberg is that the population of Zurich created it. The collector Eduard von der Heydt said he would offer his private art collection to the city of Zurich if they gave it a home in the Wesendonck Villa, so they brought it to a democratic vote in 1952. The incredible thing is that the people of Zurich voted for it, something I'm not sure would happen today when the public seems less willing to support the arts.

And I love this piece because it has so much in it. Nataraja is one of the forms of the Hindu god Shiva, and the image became famous or fashionable in Europe by the early twentieth century because of exoticism and Orientalism but also through interest in modern dance. The title of a book about this sculpture by Rietberg curator Johannes Beltz describes it as the cosmic dancer.

You can see Shiva is dancing energetically with four arms moving. His right arm is beating a drum symbolizing the creation of the universe, with the other hand preserving it. One of the left hands holds a small flame, a symbol of destruction that is clearly not the end but part of the larger cycle: exploding as a way of creating something new. The god is standing on the demon of non-knowledge, trying to keep it down. Hinduism says this is a male god, but he also looks female and beyond gender to me.

When I was a teenager, I became convinced that going to discothèques and dancing to music was a way to envision a deeper meaning, as shaking our limbs is linked to the perpetual movement of atoms and their particles. We are machines driven by blood without seeing the smaller parts of our nervous, digestive, or respiratory systems. I feel that dancing is a way of accessing the subconscious that drives our movements, offering options for going beyond our fears.

I know this Shiva is a rigid form made of metal, not gas or liquid, but it's a symbol of something very alive. All cultural expression is, I think, a wish to understand the physical universe and its laws of motion, gravity, and energy. It's an attempt to understand the other but also to understand your vast inner self.

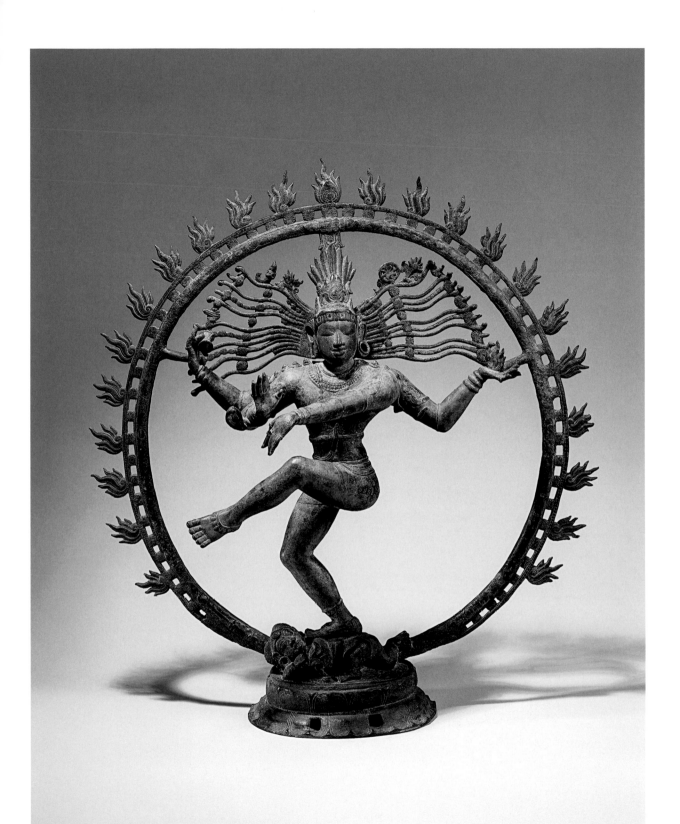

Julião Sarmento

on Domenico Ghirlandaio's
Portrait of a Young Woman

Circa 1485. Tempera on wood, 17 5/16 × 12 5/8 in. (44 × 32 cm)
Calouste Gulbenkian Museum, Lisbon

If I had to choose my ten favorite artists in the world, Ghirlandaio would probably not be on that list. But I keep going back again and again just to look at this painting—it's that beautiful. It's one of the jewels of the art world, a masterpiece that some people might not even notice, small but powerful. For me, this portrait is almost as mesmerizing as La Gioconda, the *Mona Lisa*.

From the way she's dressed, fairly plainly in the Florentine style of the day, you can guess she's a normal girl. Maybe she's someone who cleaned Ghirlandaio's house like the sitter for Vermeer's *Girl with a Pearl Earring*. But she has a presence or aura that you could describe as holy. She has the presence of a Madonna or a young Virgin Mary.

The colors are truly beautiful—the red of her coral necklace most of all. I once read that one of the best examples of product design ever made was the pack of Lucky Strike cigarettes: a white rectangle with a large red dot in it, which calls your attention to it immediately. And here the first thing that you see is the red necklace. Without the red necklace, she could be anybody. With the red necklace, she is somebody special.

We aren't, though, given much information about her. This girl is not looking at you and not looking at the painter, she's looking to her right. There is some life in her eyes, but the rest of her face is truly blank. If you place your finger over her eyes, it's really hard to tell if she's happy or sad, amused or suffering, in the same way it's hard to read the *Mona Lisa*.

Ghirlandaio just doesn't give you much. You have to build up a story about her yourself. You have to live with the doubts. This painting has nothing to do with my own work, but I did call one of my shows, a survey in Spain, *Withholding*. I am very interested in this withholding of emotion.

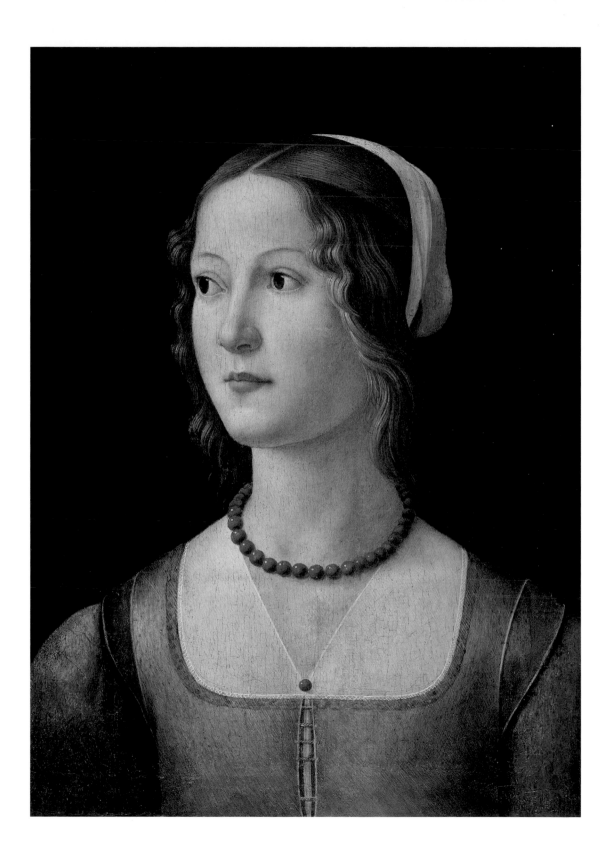

Mithu Sen

on an Indus Valley Civilization male torso

Circa 2500 BCE. Harappa. Stone, 3 ⅝ × 2 ³⁄₁₆ × 1 ³⁄₁₆ in. (9.2 × 5.5 × 3 cm)
National Museum of India, New Delhi

I've always been interested in ancient civilizations and learned about this male torso early on in schoolbooks. It was part of the Indus Valley Civilization, a great urban civilization that developed along the riverbed between what is now Pakistan and India starting some 5,000 years ago, around the same time as Mesopotamia. After the partition in 1947, the area was divided between Pakistan and India.

The big excavations started happening in the 1920s, like those led by archaeologists John Marshall and Rakhaldas Bandyopadhyay. They found quite a lot of things, including many miniature statues, mostly terracotta and metal. But this particular statue was a mystery because red sandstone did not exist in the region.

Its form is also a mystery. The most popular sculpture from the Indus Valley Civilization is a prehistoric bronze known as *Dancing Girl*. And like so many figures from this period, her body is highly stylized with straight arms and legs.

This male torso, though, is so realistically modeled, it could have been made today. The torso is so extremely, humanly fleshy. Just look at the abdomen: you can almost feel the skin and body warmth there. And the body is clearly Indian. It could be mistaken for a Greek body, but historians have concluded that it's a male Indian body especially because of the abdomen—no six packs. Still, nobody knows why or how it was made.

I first saw it in person when I was twenty or twenty-one, working on my master's thesis, and came to Delhi to do some research in the National Museum. Before starting my research, I went straight to these Indus Valley galleries. Seeing the torso surprised me because it's so tiny and so beautiful. It's also vulnerable—its head is missing, and its penis, the male part of the male body.

As a feminist artist, I've always felt this statue was made by a woman artist. I don't think it was made by *looking* at a male body but by *feeling* it. Maybe it was made by a blind artist.

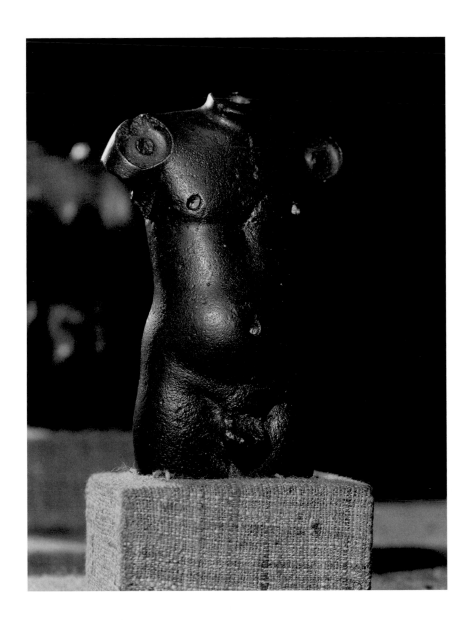

Stephen Shore

on the Gubbio Studiolo

Circa 1478–82. Probably designed by Francesco di Giorgio Martini; made by
Giuliano da Maiano. Walnut, beech, rosewood, oak, and fruitwoods inlaid in walnut
The Metropolitan Museum of Art, New York

When friends of mine are visiting New York and ask what to see at the Met, the Gubbio Studiolo is the first thing that I mention. I figure they'll find their way to the other stuff, but this is something you might not find if you don't already know it exists.

It's a small room made entirely of wood veneer, carved wood pieces in different hues that have been painstakingly inlaid to create the appearance of a three-dimensional study or library. It appears as if some stringed musical instruments, like a lute, are hanging from the bookshelves and casting shadows. But there are no actual shadows anywhere, just darker pieces of veneer. There are no books or instruments either, nothing three-dimensional in the room except for the person viewing it.

It's not confusing, you wouldn't think you were actually inside someone's library, but I do find it marvelous in a way. When you're in the space, you're overwhelmed by how much effort and exactitude went into this. Every shadow is cast perfectly. There are many examples of very convincing trompe-l'oeil paintings in the world, but this is the only trompe-l'oeil piece I know of made out of wood veneer, and that adds to my sense of wonder.

I've been visiting this room for almost twenty years now, and I know a number of other photographers who are attracted to it as well. One of the things we as photographers have to confront is that we're taking a three-dimensional world that flows in time and recording it on a static, two-dimensional surface. So something we often think about is how that translation is made from the real world to the world of photographs. Whoever made this library faced a similar challenge.

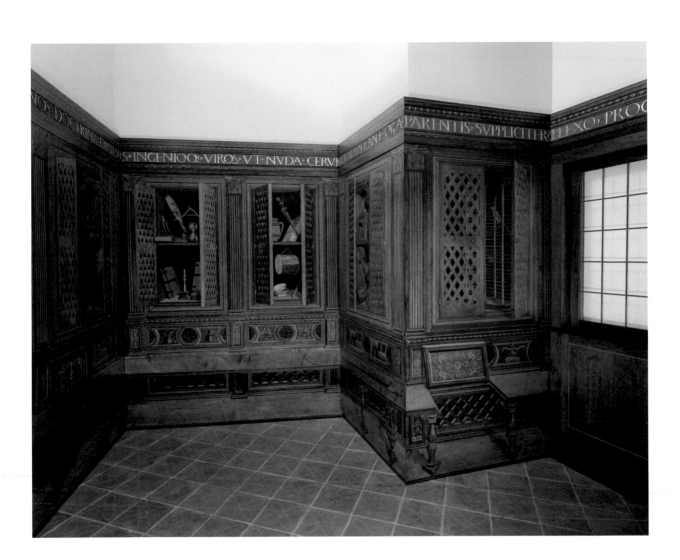

Shinique Smith

on Robert Rauschenberg's *Canyon*

1959. Oil, pencil, paper, metal, photograph, fabric, wood, canvas, taxidermied eagle, pillow, and other materials, 81¾ × 70 × 24 in. (207.6 × 177.8 × 61 cm)
The Museum of Modern Art, New York

This work feels like a neglected truth to me. It seems forgotten, perhaps because of the worn, weathered nature of some of the collage elements, but it also feels very current.

I first encountered the piece as a kid at the Baltimore Museum of Art, where it was on loan for years. At first I briefly thought it was by a black artist, I think because of the use of humble materials and everything I knew about collage from Romare Bearden. Also, it has this pain to it. The painting felt like Baltimore to me: the background looked like an urban landscape with a raven in front of it. I thought it was a raven because in Baltimore we were always reading Edgar Allan Poe and visiting his grave on Halloween.

Now, knowing the bird is an eagle, it feels very American and Native American. And it's flag-like in many ways. You can see bits of red, white, and blue above the eagle, and the word "labor" is prominent. That is very American to me, and the presence of the eagle and that large white stripe to the right help to anchor that feeling. I'm also interested in his use of blackness and the black gestural marks that seem to be scratching something out. From a different angle, they could be seen as other eagles in the distance, like a small flock.

Another thing I noticed recently is that Rauschenberg used a white button-down shirt in there, which is so interesting socially. I've used the white button-down too—it's the business shirt, a symbol of striving and privilege, usually white male privilege. Then the pillow hanging off the stick reads to me like something a hobo might carry, maybe a nod to the veterans in the 1950s who were homeless.

There is definitely this disillusionment and melancholy in the work, political-social implications about labor and loss. And the black eagle looks like it's covered in oil.

Still, the title *Canyon* has always eluded me. Why did Rauschenberg call it *Canyon*? I'm picturing this deep gorge or fissure that gets wider from erosion. Maybe he was trying to say that America is like a chasm? I can't help but think this, with the social, economic, and racial injustices and violence going on right now in this country.

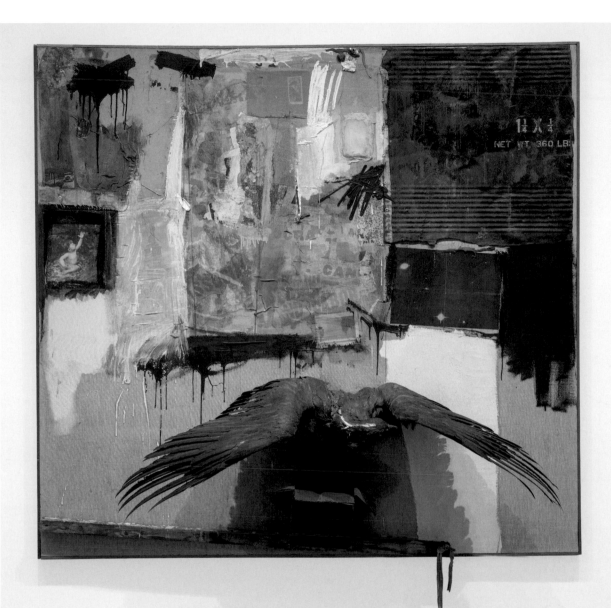

Mounira Al Solh

on a Palmyran funerary relief

161 CE. Bust of a woman, inscribed "'Aha daughter of Halafta son of Bar'a Zabdateth"
Limestone, 27 × 19 × 11 7/16 in. (70 × 48.5 × 29 cm)
Archaeological Museum, American University of Beirut

Palmyra is famous for being an important cultural site, a touristic site attacked by ISIS. But for many locals, it was infamous for having a scary jail run by the Syrian regime. I'm Lebanese and grew up during the Lebanese Civil War, and my mom is from Damascus, so we used to spend time in Syria for family matters and also whenever there were too many bombings and shootings in Lebanon. We sometimes drove past Palmyra, but never to it.

So I've never been to the site, but I'm fascinated by the nine Palmyran funerary relief sculptures on display at the Archaeological Museum in Beirut. Almost lifesize, they were mounted on tombs to represent the people buried inside. The carvings often included something alluding to their social status or occupation, like the German New Objectivity painters showing the doctor with his tools or the painter with his brushes.

By the time these sculptures were made, in 100 to 300 CE, Palmyra had became an important commercial trading center, a major stop on the Silk Road, with Rome to the West and Persia to the East, which made it quite wealthy. And it was a crossroads for many cultures and languages, so these funerary busts combine Western and Eastern aesthetics.

You can see that in this bust of a woman. Her face—in particular, her profile and nose—looks quite Greek to me. But the sculpture was made of limestone, which is common to this area—this is the source of the name of Lebanon, some say—and her pendant earrings and jewelry look Eastern, as does the headdress that wraps around her arm.

The dramatic hand gesture, the way the woman holds her hand under her cheek, also looks Eastern to me. It makes me think of a famous picture of Asmahan, the Syrian singer who in the 1940s died mysteriously in a car accident. And if I were to draw a portrait of my mom or a respectable chic woman, she might assume the same pose. It's a good pose for a lady of leisure, someone who is perhaps not a traditional housewife but making a contemplative gesture.

When I look at this fancy bust now, I can't help but feel sad about how much the region is struggling today. Palmyra was a rich oasis in the middle of unrest because all the cultures were interacting. This is what we need today: a sense of openness and working together despite our differences, which is impossible under everlasting dictatorships.

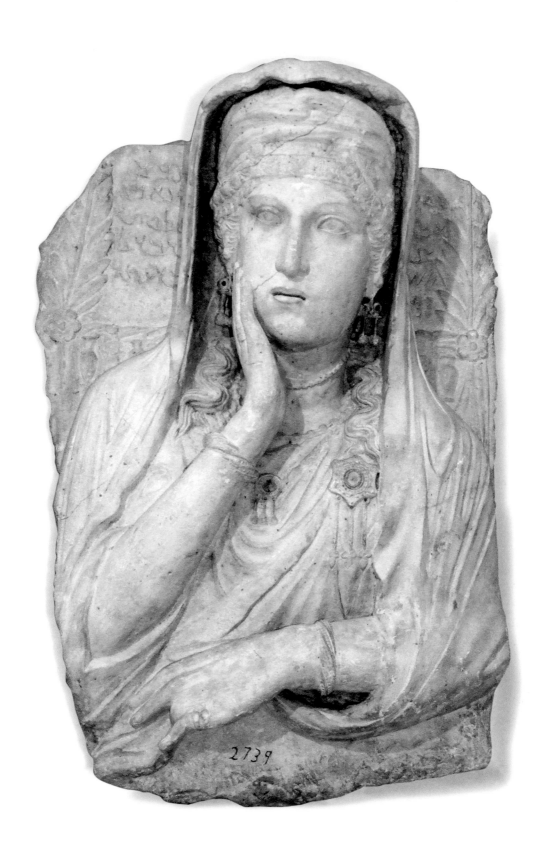

2739

Kishio Suga

on Richard Long's *Tokyo Stone Line*

1983. Stone, 76 ¾ × 445 ½ in. (195 × 1132 cm)

The National Museum of Modern Art, Tokyo

I often make works using stones and pieces of wood that I find in the natural environment. I don't know where Richard Long obtained these stones, but it's unusual to find such pointed stones in nature. I wonder if they were cut. Looking at them arranged on the floor, they are reminiscent of a jagged mountain landscape.

Long has made other works by placing long and narrow stones on their ends, perhaps because you would almost never find such a situation in nature. In other words, one can feel the consciousness of making.

No single stone is the same, in terms of size, shape, or mass. But gathered together, the accumulation of the stones captivates me. What I find interesting is how the overall installation, a rectangular shape, is expressed as a collective of individual stones. When you perceive this work in terms of individual units and the whole, it raises the question of whether the work could exist if even a single stone were removed.

I can imagine that this work would make a very different impression if the stones had been placed in other ways. Because the stones are mostly angular, they introduce a scenery of dissimilarity in a space that has flat walls and a flat floor. The layering of one stone against another results in areas of visibility and invisibility—a narrative about the depth of space, scenery, and multiplicity.

This piece seems typical of the artist's work to me. It's a vestigial situation—something that emerges out of the artist's process. I get the feeling that Richard Long as a person disappears into nature. I think that's a wonderful state of being.

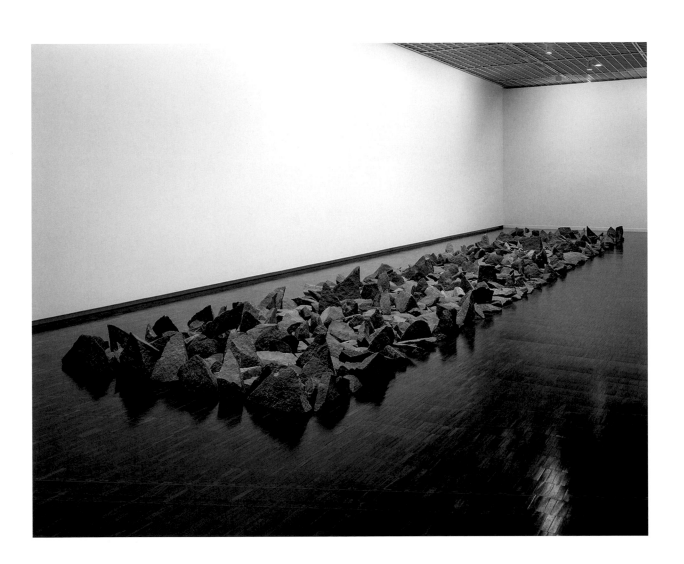

Do Ho Suh

on Jeong Seon's *Inner Geumgang*

Circa 1750. Ink on paper, 11 ⅛ × 31 ¹¹⁄₁₆ in. (28.2 × 80.5 cm)
Kansong Art Museum, Seoul

The Kansong is a very special museum, a three-minute walk from my parents' place, my childhood home, in Seoul. "Kan" means "stream" and "song" means pine tree, and the neighborhood is known for its tall red pines, which is one reason my father chose to have his home there. The museum was founded in 1938 by Jeon Hyeongpil with a mission to buy back Korean works that had been sold or maybe stolen during the Japanese occupation. A lot of its collections are now designated "national treasures" in Korea, but I think its real strength is paintings from the Joseon Dynasty, especially starting in the eighteenth century.

That's a period when Korean economic and cultural powers really deepened, and artists gained the confidence to look at their own culture and begin a "true-view" Korean landscape movement. The scholar-painter Jeong Seon was at the center of this movement and created a large body of landscape painting. This fan painting is a great example of his work.

If you look at the mountain depicted here, it might not look real because it has so many sharp peaks. Instead of working from a single perspective point like in Western art, Jeong is showing the landscape as movement, reflecting the Asian philosophy that nothing is permanent and everything is in constant flux. But he actually painted this work after visiting a real mountain in North Korea called Geumgang, or Diamond, Mountain because of its jagged rock formation. This is important because before this movement, Korean painters instead depicted famous Chinese landscapes.

What I also find fascinating is how the painting functions differently than it would in Western tradition. In the museum, we see the ink painting on paper, but it was originally mounted on thin slices of bamboo to be used as a fan. It was a functional object, something a Korean scholar would carry, like a gentleman in London would carry a well-made umbrella. And it's meant to be folded, so it's a very portable painting. You can carry the landscape in your hands.

That's not an isolated situation. We also see landscapes painted on the folding screens that Korean scholars loved to bring out into nature with them when they were writing poems, for instance, and of course traditional paintings took the form of rolled paper. They're all about movement, about transporting a space. In a way, my fabric pieces are like this too—attempts to transport my very intimate spaces somewhere else.

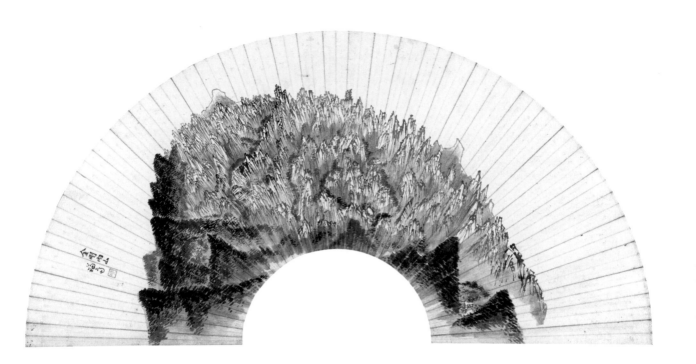

Diana Thater

on Nam June Paik's *Video Flag Z*

1986. Television sets, videodisks, videodisk players, and Plexiglas
modular cabinet, 74 × 138 × 18 ½ in. (187.9 × 350.5 × 46.9 cm)
Los Angeles County Museum of Art

Nam June Paik is one of my heroes, and this is the only major work by him in a public collection in Los Angeles. It's a grid of eighty-four Quasar TVs laid out in the form of an American flag; one channel feeds all the screens on the top left section with images of stars, and the other channel gives us the stripes. The stars and stripes are constantly changing: images fold, multiply, and zip across the screens. The flag is constantly, wildly in motion. Scenes from movies dissolve in and out. It's an exuberant work full of color and recognizable signs, corny shapes like hearts and stars, and famous figures such as Marilyn Monroe and Allen Ginsberg.

We're very familiar with the idea of early video art as a critique of television or entertainment, like the feminist critique of mass media. But I don't think this work is a critique at all, it is instead a vehicle for Paik's enthusiasm for the possibilities inherent in his medium. Paik had a truly optimistic perspective. He once spoke about looking forward to the time when the "TV Guide will be as fat as the Manhattan telephone book." He thought that mass media had an incredibly open future that promised some kind of equality for people through the spread of information, by giving everyone access to all information, all at once and all the time—looking forward to what the internet could be, but isn't, today.

Video Flag Z is pure pop with its flashing hearts, stars, flags, and Marilyns. On another level, though, the piece is abstract. It creates no narrative and mocks the quaint idea of linear time. For Paik, as a Fluxus artist, there is no inherent meaning in the progression of history, in the ticking of the clock. There is only meaning in the simultaneous and chaotic flow of life.

So the work encourages us to let go of the desire to link moments one after another into a comprehensible story—it opens us up to being completely in the present. It has a kind of living beauty that is best expressed in the moving image.

Rirkrit Tiravanija

on Montien Boonma's *Venus of Bangkok*

1991–92. Bucket, wood, paint, bricks, sponge, and metal,
67 ⅜ × 69 ½ × 37 in. (171 × 177 × 94 cm)
MAIIAM Contemporary Art Museum, Chiang Mai, Thailand

In the 1990s, Montien Boonma was one of the only Thai artists getting exposure outside of Thailand, with international biennials and shows in New York. He was a professor in Chiang Mai, where he taught a lot of younger artists and shared my work with some of them. He was generous to many of us.

This *Venus* is one of his earliest sculptures, made in 1992. Before then, he was better known as a printmaker and painter. Later, his most famous works were like medicine cabinets, filled with real herbs that you could breathe in to help heal you.

Venus looks like a Rauschenberg *Combine*: a lot of scrappy things put together. A large wood crate acts as the base, and then on top is a layer of red bricks with what I would call the figure: the twisted metal and wood and a tin bucket, holding a reddish pink sponge. That form reminds me of a reclining figure by Henry Moore.

Others have interpreted *Venus* as some kind of Thai prostitute, thinking about how the original *Venus de Milo* is sexualized and about how Bangkok during the Vietnam War became a source of R&R for soldiers, and it still has that reputation. But I've found a little text by a Bangkok gallerist, Numthong Sae Tang, who said *Venus* was Montien's monument to all the women who worked in construction sites in the early '90s, during the hyper-urbanization of Bangkok. You can see how the tin bucket and bricks could belong to a construction site. The sponge could have been used to clean the walls.

I wouldn't be surprised if Montien even picked up these pieces at a construction site. There's a story about how this work was traveling once to Malaysia for an exhibition, and it got stuck at the border. The border guards kept looking at these wrapped-up pieces of garbage trying to figure out why anyone would transport them anywhere.

Montien always said to me that he saw himself as a craftsperson. That's part of the tradition of being a Thai Buddhist artist: making things in service of the temple, anonymously. I think in that way he relates to the women in construction who work without recognition. He was a bricklayer of sorts too.

Luc Tuymans

on Jan van Eyck's
The Virgin and Child with Canon Joris van der Paele

1434–36. Oil on panel, 48 1/16 × 62 1/8 in. (122.1 × 157.8 cm)

Groeninge Museum, Bruges, Belgium

This was my first van Eyck. I visited it as a kid in Bruges, which is a tourist destination even for the natives. What shocked me is the exactitude of the painting and the way he depicts materials in their variety, from the opulent jewels on the crown to the blue-and-gold brocaded cloth of the bishop, which I recently photographed and blew up a little square of to paint for myself. The level of detail is insane.

The painting was ordered by the canon Joris van der Paele, who in his day was an important person in the city of Bruges, which at that time was considered the Venice of the north, a very prosperous city. In the picture, he appears in the white robe at the right, praying, very close to the Virgin and Christ Child. The painting was designed to empower the person who ordered it—an expression of his piety and also his wealth.

The blue and gold of the bishop's robe especially stay in my mind. The gold was not made with gold but painted with yellow highlights. The blue, one of the most costly colors to make, came from the lapis lazuli stone. It's a cool prospect of blue, not a warm blue. It's a royal blue that has everything to do with perfection.

There's a hardness to this work. Everything in the picture is treated with an enormous amount of attention, every space is solidified, nothing left open or to chance. It's a very well constructed, conceptualized, and ultimately produced picture. There's nothing unfinished about this.

At the same time, the element of mortality is instantaneously there in the bodies, the faces, the deep wrinkles of the canon's face. If you blew up one of the faces in the painting to the size of a house, it would still look like a face. It has that level of detail. When you're in front of the painting, even though it's not lifesize, it feels like someone is breathing on your neck.

I am thoroughly convinced that there is no better painter than Jan van Eyck in Western art. There is no real competition. When you come from this region and start as a painter, you are instantly traumatized by his heightened sense of perception, also perfection. After van Eyck, every painter is a dilettante.

Bill Viola

on Dieric Bouts' *The Annunciation*

Circa 1450–55. Distemper on linen, 35 7/16 × 29 3/8 in. (90 × 74.6 cm)

The Getty Museum, Los Angeles

This is one of my favorite paintings in the Getty and in the world. I was a scholar in residence at the Getty Research Institute in 1998 and spent a lot of time with the picture then. I was so taken by it that I returned to it after I had the unfortunate experience of seeing an elderly gentleman die, with the paramedics working on him right outside the Getty entrance. So I went inside to the painting for solace—and found it even more moving and powerful.

It's austere and subdued, both in terms of the figures in it and the light and shadow of the empty room. It's almost Zen-like. There's an incredible blood-red curtain in the back—I get goose-bumps whenever I see it. But otherwise, there's very little color, which is strange because the Northern European painters like Rogier van der Weyden and the van Eyck brothers were all about color. Here it's so muted.

The scene is internalized in a powerful way. Think of that beautiful Fra Angelico *Annunciation* in San Marco in Florence, where Gabriel is walking onto the veranda and Mary is looking right at him. But here the communication is happening the way all sacred conversations happen, without eye contact and without dialogue. This stillness is what attracts me.

And the subject is probably the most profound in human existence: the moment when a woman knows she's pregnant. That's when you go beyond Mary, Jesus, and Christian iconography and enter the universal language of humankind. This painting represents something universal and essential for our existence. Like Rumi said: "Woman is a ray of God, she is not that earthly beloved; she is creative, not created."

Edmund de Waal

on Pieter Jansz. Saenredam's
The Interior of the Grote Kerk at Haarlem

1636–37. Oil on oak, 23 7/16 × 32 3/16 in. (59.5 × 81.7 cm)

National Gallery, London

It might seem a bit wayward to choose Saenredam because he wasn't Rembrandt or Vermeer or Pieter de Hooch. He mainly made pictures of church interiors. But I've loved his work since childhood. You can't legislate what really matters to you.

For me, he's a kind of proto-minimalist, with a passionate excitement for structure. There is a type of austerity that is alienating, antihuman, and chilling. Then there's austerity that is really a kind of lucidity or clarity, which comes out of a real, true feeling for how light and space work. Saenredam has this quality.

The first thing you notice in this picture are these great columns, and then you have this extraordinary rhythm of columns and arches unfolding. It feels almost musical, this rhythmical cadence of light and shade and this beautiful palette with different whites and grays. It's like looking at artwork by Donald Judd or Sol LeWitt, which reflects this incredible understanding of structure.

And the figures are not there just for scale. Look at the man near us, wearing his formal clothes and sitting down with a prayer book. I think he indicates what the whole picture is about—contemplation. He's not gazing at an icon or picture or cross but looking out into the space itself, and I have this feeling that I'm there with him, in his seat. You can also inhabit the woman sitting with her basket on the floor, you can feel the stoniness of the floor and cold of the pillar. In Saenredam's other paintings, you see a dog taking a pee in the church or a boy doing graffiti on the wall.

That's what I want to make in my own work: something that has a lot of light and space in it and also enough room for the raggedy ordinariness of life to inhabit it as well.

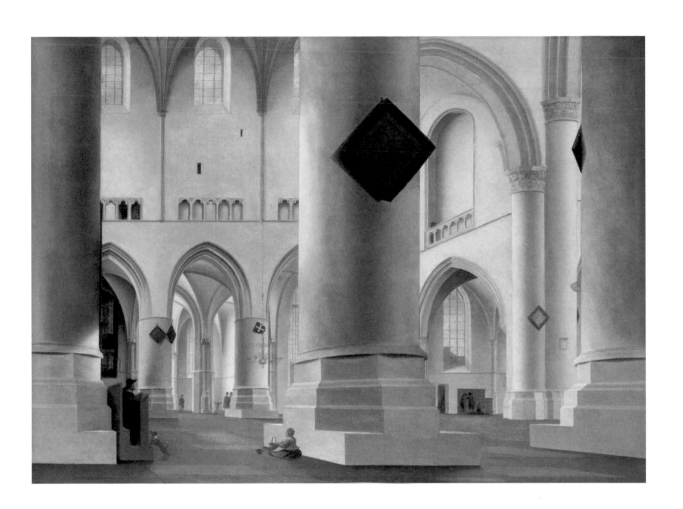

Gillian Wearing

on **Rembrandt's**
Self-Portrait at the Age of 63

1669. Oil on canvas, 33 ⅞ × 27 ¾ in. (86 × 70.5 cm)
National Gallery, London

I fell in love with Rembrandt when I was doing a two-year course at the Chelsea School of Art in the 1980s and started making self-portraits—paintings and drawings. I would go to the National Gallery to draw, which students back then used to do, and I loved the simplicity of this painting, with light hitting the face and darkness all around. It's almost cinematic the way Rembrandt lights up the face. Everything else fades away by comparison. It's a portrait that directly gives you a sense of the artist as a person, as basic as can be, no props, no symbols.

Rembrandt made almost a hundred self-portraits over the years and made this one in 1669. It's one of his final portraits; he died later that year, though we don't know exactly how. When he's younger, you see him posing more, playing a character or traditional role or showing off his elegant clothes. Here, you can barely see his cloak, and you don't get any sense of posing. There's no vanity here. He looks a bit tired and weary. He looks completely natural, vulnerable, almost like a photograph where someone is caught off guard.

What I find really beautiful is the delicacy of his skin. His face looks almost like a landscape, with these tiny undulating areas from his forehead to the skin below his eyes. The palette throughout is beautifully muted, with bits of dark red in the cloak and the yellow tones of the flesh. I imagine there are layers of green and blue paint beneath to bring out the blood underneath the face.

I remember one of the first documentaries I loved on television was *Seven Up!*, where Michael Apted followed children in the U.K. beginning at seven years old and returning every seven years. That felt revolutionary to me, to make a record of these people and how their lives, livelihoods, and personalities changed over time. But Rembrandt did it earlier in a way. I love that you can look at his series of self-portraits and see how he changes physically and psychologically over the years, a sort of diary of aging.

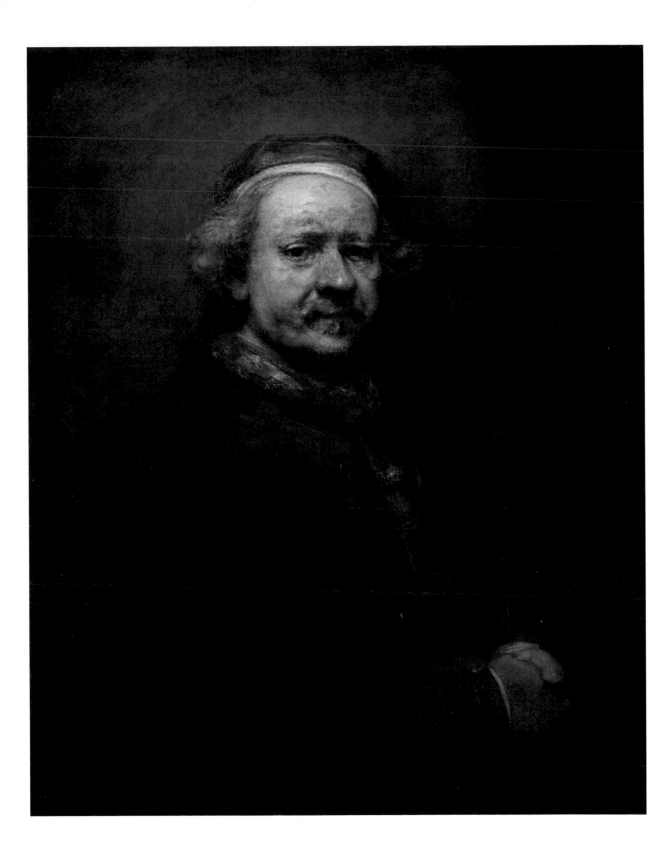

Lawrence Weiner

on Willem de Kooning's
Door to the River

1960. Oil on linen, 80 ⅛ × 70 ⅛ in. (203.5 × 178.1 cm)
Whitney Museum of American Art, New York

I have always been a fan of Willem de Kooning, but this painting was also a rite of passage for me: it was a door into another world. In the early 1960s, before the Whitney had its Breuer building, the museum was located on 54th Street right next to the Museum of Modern Art. There was a doorway with a few steps leading from the old Whitney to the old Modern, and I would tell people to see this wonderful painting hanging there called *Back Door to the River*, but I got the title wrong. It was *Door to the River*.

It's a really beautiful painting with these yellow streaks. It felt like the culmination of all the Abstract Expressionists I grew up with, showing the purpose of the artist's quest: to understand real-life space without portraying real-life space. Pollock with his spirituality was always trying to prove he was pure, but de Kooning was not afraid of color. He saw the world through a prism of color.

Going against everything I do now, as a young person I read this painting as a metaphor with those yellow streaks creating a doorway. I saw it as a doorway into another world, a rite of passage of wonderment, a chance to drop down Alice's hole.

I felt the same way about an Oskar Schlemmer painting, *Bauhaus Stairway*, that used to hang in a staircase at the Modern leading to the galleries. That painting shows people walking up the stairs on the way to do something, like a dance class. It also carries such forward movement.

Both paintings marked for me an entrance into a space where people were doing something as opposed to life. They were a break between the outside world and the inside world of the museum. I'm thinking about the fact that there is a difference between normal culture, what people produce, and popular culture, what people consume. There's nothing wrong with consuming, but that wasn't my role even as a kid. I wanted to know what it was to be a maker.

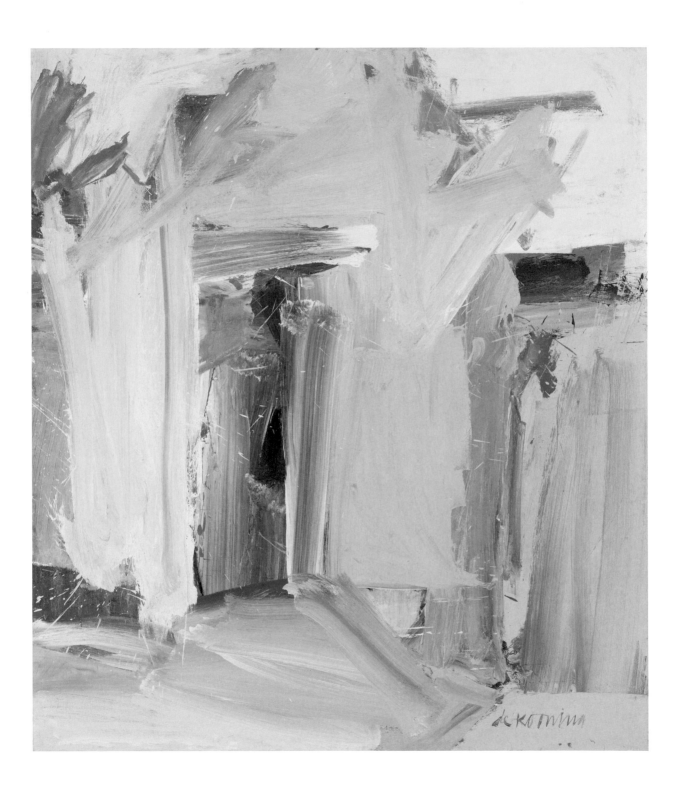

James Welling

on Andrew Wyeth's *Northern Point*

1950. Egg tempera on gesso panel, 36 × 18¼ in. (91.5 × 46.4 cm)
Wadsworth Atheneum Museum of Art, Hartford

This scene captures a familiar kind of foggy afternoon in New England, and you feel like you're perched on a weathered roof, looking out beyond a lightning rod toward the Atlantic Ocean.

I first saw *Northern Point* at the Wadsworth Atheneum when I was fourteen. I'd begun taking drawing classes, and I was amazed by Wyeth's exactness and draftsmanship. And I was equally amazed by the three-dimensional surface of the egg-tempera brushstrokes. The painting seemed alive.

More recently I saw *Northern Point* in the Wyeth centenary exhibition at the Brandywine River Museum of Art. This time, I was struck by the fact that his precise style is fully consonant with the subject he's painting. All the apexes, all the points in *Northern Point*, underscore Wyeth's intensity.

The tapering iron shaft of the lightning rod; the angle of the gable roof; and the slim, vertical pole staked in the cordgrass epitomize the sharpness and acuteness of Wyeth's unnerving, hyper-real view of the world. I was also amazed by the sundial-like shadow the lightning rod casts on the roof and the shining white highlight on the glass globe. I now understand this shadow and highlight as Wyeth's way of *fixing*, or visualizing, time.

The point of view of *Northern Point* is a bit bizarre—the artist appears to be hovering off to the left side of the roof gable. This unsettling perspective is not unlike Wyeth's uncertain placement in art history. Wyeth was a Precisionist like Charles Sheeler, a psychological painter like Edward Hopper, a Surrealist like Peter Blume. But generationally, Wyeth was working alongside the Abstract Expressionists, whom he admired.

Today Wyeth is rarely thought of in the same breath as those artists. To my mind, he is a phantom Abstract Expressionist. All those acute apexes that punctuate *Northern Point* give the work its visual dynamics and remind me of the compositional energy you'd find in a Franz Kline painting.

And something else in *Northern Point* connects Wyeth to his peers. It's that startling highlight that sits atop the globe of the lightning rod, that tiny explosion of blinding white light against the lifting fog, that bright instant, fixed for all time.

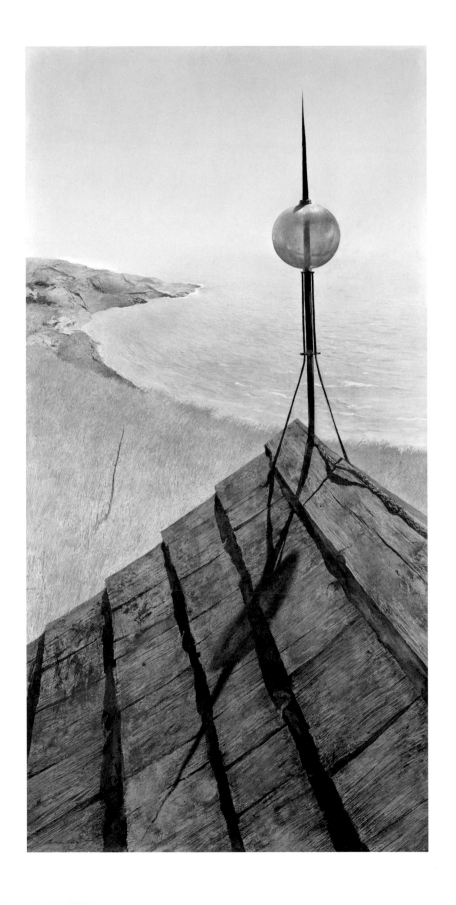

Contributors

Marina Abramović

(b. 1946 in Belgrade, Yugoslavia, now Serbia; lives in New York) has pushed the boundaries of high-intensity, long-duration performance art since the 1970s. Often, her physically and psychologically demanding performances are designed to break down boundaries between artist and audience. In *Rhythm 0* (1974), Abramović allowed herself to be acted upon by audience members with 72 different objects, including scissors, a rose, and a gun. For *Balkan Baroque* in the 1997 Venice Biennale (for which she received the Golden Lion award for best artist), she scrubbed 1,500 bloody cow bones during four days for six hours a day. In *The Artist Is Present* (2010), Abramović sat quietly on a wooden chair at the Museum of Modern Art in New York for eight hours a day, inviting visitors to sit across from her and make eye contact in a performance that explored the cathartic powers of human connection.

Ulay / Marina Abramović, *Relation in Time*, 1977.
Photograph from a 17-hour performance at Studio G7, Bologna. Stedelijk Museum, Amsterdam

Ai Weiwei (b. 1957 in Beijing; lives in Berlin) uses his art to expose abuses of power by state governments and other institutions. With *Remembering* (2009), he excoriated the Chinese government for the flimsy construction of schools in Sichuan by arranging 9,000 children's backpacks on the facade of the Haus der Kunst in Munich to spell out a quote from a mother whose child had died because of the negligence. Ai's activism led to his 81-day incarceration and the seizure of his passport by Chinese authorities in 2011. He still could not travel internationally when his exhibition *@Large* took over Alcatraz in 2014, with one highlight being portraits of political prisoners composed of LEGO bricks. After his passport was returned in 2015, he traveled to 23 countries to film footage for *Human Flow* (2017), an acclaimed documentary about the international refugee crisis.

Trace, 2014. Floor portraits made of Legos. Installation view from *@Large*, produced by For-Site Foundation on Alcatraz Island, 2014. Hirshhorn Museum and Sculpture Garden, Smithsonian Institution, Washington, D.C.

Leonor Antunes

(b. 1972 in Lisbon; lives in Berlin) creates floor-based sculptures, wall hangings, and curtainlike forms that prove less functional and more philosophical than they might seem at first glance. She often uses craft techniques borrowed from Latin American artisans and revisits the forms of female modernists like Anni Albers and Eileen Gray. Some of her most acclaimed works consist of vertically hung, gridlike nets that are hand-woven with materials such as hemp rope and do not maintain their strict geometric shapes, recalling Portuguese fishing nets. These "grids" are prime examples of how Antunes reconciles in her literally open-ended sculptures the rigid ideals of modernist aesthetics with traditional craft making.

Artigas, 2014. Brass tubes, brass wire, and kambala wood, 133 ⅞ × 67 × 1 ¹⁵/₁₆ in. (340 × 170 × 5 cm).
Installation view from the 8th Berlin Biennial. Serralves Museum, Porto

Ilit Azoulay

(b. 1972 in Tel Aviv; lives in Berlin) is a photographer with a strong conceptual, archival, and narrative bent, known for extracting the stories embedded in forgotten or discarded objects. For *The Keys* (2008–10), she visited buildings in Tel Aviv that were slated for demolition, discovering objects such as keys, shells, and broken toys that had been used to pad the shoddily constructed "austerity period" walls from the 1950s and '60s. For *No Thing Dies* (2014–17), she spent many months in the storage rooms of The Israel Museum in Jerusalem researching artifacts excluded from display and sidelined from the official history of Israel. Both series, which culminated in photomontages, explore the imprint of economics and politics on material history.

Room #8 (detail), 2011.
Inkjet print, 60 × 392 ¾ in. (152.5 × 997.5 cm). Centre Pompidou, Paris

TIPS FOR ARTISTS WHO WANT TO SELL

• GENERALLY SPEAKING, PAINT-
INGS WITH LIGHT COLORS SELL
MORE QUICKLY THAN PAINTINGS
WITH DARK COLORS.

• SUBJECTS THAT SELL WELL:
MADONNA AND CHILD, LANDSCAPES,
FLOWER PAINTINGS, STILL LIFES
(FREE OF MORBID PROPS...
DEAD BIRDS, ETC.), NUDES, MARINE
PICTURES, ABSTRACTS AND SUR-
REALISM.

• SUBJECT MATTER IS IMPOR-
TANT: IT HAS BEEN SAID THAT PA-
INTINGS WITH COWS AND HENS
IN THEM COLLECT DUST
... WHILE THE SAME PAINTINGS
WITH BULLS AND ROOSTERS SELL.

John Baldessari

(b. 1931 in National City, California; lives in Los Angeles) is a ground-breaking Conceptual artist who has long mined the uneasy relationship between written text and visual image. For an early work, *I Will Not Make Any More Boring Art* (1970–71), Baldessari asked students of the Nova Scotia College of Art and Design to write that phrase repeatedly on the walls of their gallery space. The act recalled an old-fashioned, rote-learning, schoolboy punishment, but actually through its messaging prized nonconformity. The artist himself has resisted developing a signature style through decades of making collages, photographs, prints, and paintings.

Tips for Artists Who Want to Sell, 1966–68.
Acrylic on canvas, 68 ¼ × 56 ½ in. (173.4 × 143.5 cm). The Broad, Los Angeles

John Bock

(b. 1965 in Gribbohm, Germany; lives in Berlin) specializes in perplexing performances and confusing art objects that owe something to the Dadaists, a group of artists who responded to the outbreak of World War I with linguistic anarchy, visual absurdity, and theatrical farce. Called a "German multimedia wizard" by critic Roberta Smith, he makes complex sculptures and installations that are hard to situate or explicate. These often figure in the frenzied performances that he ironically calls "lectures" and videotapes for later use in installations, creating microcosms where actions, objects, and language are interdependent. Bock has also made several films, including one about a nineteenth-century inventor, *Dandy* (2006), which is as remarkable for its bizarre costume contraptions as for its parody of mad-genius tropes.

When I'm Looking into the Goat Cheese Baiser, 2001.

Photograph from an installation and performance at Anton Kern Gallery, 2001. Prada Foundation, Milan

Mark Bradford

(b. 1961 in Los Angeles; lives in Los Angeles) makes large-scale paintings that explore the sociopolitical potential of abstraction, what he calls "social abstraction." To this end, instead of using a paintbrush and paints, he typically gets his color and texture by layering scraps of papers and found materials, such as newsprint, comic strips, hair-salon endpapers, and posters for businesses or services that he finds on the streets of his neighborhood. A favorite source material, these gritty "merchant posters" are loaded with urban context and community, reflecting the economic conditions of marginalized populations. In 2017, Bradford represented the United States at the 57th Venice Biennale with *Tomorrow Is Another Day*, an epic—also mythic—installation exploring American racism, from its historical roots in slavery and the Civil War to its role in contemporary mass movements such as Black Lives Matter.

Thriller, 2009. Mixed-media collage on canvas, 101 × 142 in. (256.5 × 360.7 cm).
Museum of Contemporary Art Chicago

Pia Camil

(b. 1980 in Mexico City; lives in Mexico City) works with the urban fabric of Mexico—and sometimes with its residents as well—to upset the conventions of consumer society and the commodity-based art market. For *Wearing Watching* at the 2015 Frieze Art Fair in New York, Camil designed and gave away 800 different ponchos made of brightly dyed secondhand fabric, billed as "habitable paintings" in the spirit of Brazilian artist Hélio Oiticica. For *Bara, Bara, Bara* at the Dallas Contemporary in 2017, she hired seamstresses to combine cut-up t-shirts bought from Mexican street vendors into the kind of large canopies found at outdoor markets. She has also made artworks based on the city's leftover billboards, abandoned buildings, and low-rent store displays, with high modernist art providing another source of imagery.

Espectacular Telón Pachuca I & II (Billboard Curtain Pachuca I & II), 2014.
Hand-dyed and stitched canvas, diptych, each 106 ¼ × 151 in. (270 × 384 cm). Installation view
from an exhibition at Gallery OMR, Mexico City, 2014. Jumex Museum, Mexico City

Nick Cave (b. 1959 in Fulton, Missouri; lives in Chicago) has been crafting his exuberant, electrifying *Soundsuits*, which draw on Trinidadian carnival costuming, since 1992. Working on multiple levels, these artworks can be shown as static sculptures in galleries or worn as second skins by dancers, including Cave, who create sound through movement. The first *Soundsuit*, his artistic response as a black man to the beating of Rodney King, was composed of dried-out twigs; since then, he has used everything from colorful buttons and sequins to children's toys. By rendering the wearer's race and gender unidentifiable, these extraterrestrial disguises also imagine an escape from painful and limiting stereotypes. Along with Cave's other installations and sculptures, the *Soundsuits* respond to racism and gun violence in America by highlighting the body's vulnerability and fortifying against it.

Soundsuit (top half), 2006.
Mixed media, including
synthetic hair and fabricated
fencing mask.
H. 72 in. (183 cm) for full
Soundsuit on mannequin.
Seattle Art Museum

Judy Chicago

(b. 1939 in Chicago; lives in Belen, New Mexico) has been a leader of the feminist art movement since she began her epic-but-intimate installation *The Dinner Party* (1974–79). For the work, which made headlines internationally, Chicago and a team of volunteers used traditional techniques of ceramic painting and fiber art to design a table with 39 place settings, each commemorating an important female figure in mythology or history. Through a gift from the Elizabeth A. Sackler Foundation, the Brooklyn Museum acquired the work in its entirety in 2002. Subsequent series have used a range of mediums, from glass to needlework, to approach subjects such as childbirth, masculinity, the Holocaust, and the end of life. Her first memoir, *Through the Flower: My Struggle as a Woman Artist* (1975), is a cornerstone of second-wave feminism.

The Dinner Party, 1974–79. Ceramic, porcelain, and textile, 576 × 576 in. (1463 × 1463 cm).
Brooklyn Museum

Jimmie Durham

(b. 1940 in Washington, Arkansas; lives in Berlin) began work as a sculptor in 1964, at a time when he was politically active in the American civil rights movement. In the 1970s, living in New York, he became a co-founder and chairman of the International Indian Treaty Council at the United Nations, where his work, with others, led to the Declaration on the Rights of Indigenous Peoples. The following decade, Durham came to prominence for making sculptures from materials such as stones, carved wood, animal skulls, and bones. Some of his central themes—in sculpture, video and film, drawings, and also the poetry he writes—include the relationship between the environment and history, political power structures, and narratives of national identity. Durham has lived in Europe since 1994.

Malinche, 1988–91. Guava, pine branches, oak, snakeskin, polyester bra soaked in acrylic resin and painted gold, watercolor, cactus leaf, canvas, cotton cloth, metal, rope, feathers, plastic jewelry, and glass eye, 66 ⅛ × 22 ¹⁄₁₆ × 33 ⅛ in. (168 × 56 × 84 cm). S.M.A.K., the Municipal Museum of Contemporary Art, Ghent, Belgium

Mikala Dwyer

(b. 1959 in Sydney; lives in Melbourne) became prominent in the 1990s as one of Sydney's "grunge artists," who use detritus in their work. Her dynamic, open ended installations, exploring everything from paranormal events to Constructivist design, have since taken many forms. But the alchemy of found objects, rubbish or new-ish, remains a constant. She has wrapped CD players in soft felt and cocooned houseplants (with their dirt) in sheet plastic, giving them a new skin. She has made gold-glazed ceramics with trinkets buried within them. She has made sculptures from children's toys, including a chimera of small dinosaurs and dragons that she placed in a ritualistic circle on the floor—one of her favorite formations. Throughout, her process is highly improvisatory, with many installations only taking shape once the materials reach the exhibition site.

The Divisions and Subtractions, 2017.

Mixed media, dimensions variable. Art Gallery of New South Wales, Sydney

Teresita Fernández

(b. 1968 in Miami; lives in New York) is celebrated for making intricate, dazzling sculptures and installations inspired by landscapes, skyscapes, or natural phenomena like fires and waterfalls. She has worked with natural materials such as pyrite, gold, iron ore, and graphite, as well as steel, glass, and plastic, but light might be her most essential ingredient. In 2015, the artist suspended shimmering golden canopies made of mirror-polished steel disks over the pathways of Madison Square Park in New York, evoking the otherworldly mirages known as *fata morgana*. "Rather than trying to create overt landscapes, or fake landscapes, or mini landscapes," she has said, "what I'm really trying to create is an experience that offers that sense of just staring back at yourself, a quiet mirror to yourself."

Fire, 2005. Silk yarn, steel armature, and epoxy, 96 × 144 in. (243.8 × 365.8 cm).

Made in collaboration with The Fabric Workshop and Museum, Philadelphia.

San Francisco Museum of Modern Art

Lungiswa Gqunta

(b. 1990 in Port Elizabeth, South Africa; lives in Cape Town) transforms everyday objects into potent symbols of the inequalities and violence created by colonial structures in South Africa. For the 2016 installation *Divider*, she hung Black Label beer bottles from the gallery ceiling on ropes that were actually made of petrol-drenched strips of bedsheets, a visual riff on Molotov cocktails that calls out the racially charged, machismo-fueled marketing strategies of the beer company. For a 2018 exhibition, *Qwitha*, she replaced the bristles of kitchen scrub brushes with matchsticks, mounting them on the gallery wall as an installation and, for a video, strapping them on her feet as shoes—an image of domestic labor ready to ignite. Gqunta is also a member of iQhiya, a women's art collective dedicated to addressing injustices of colonialism, racism, and sexism in South Africa.

Divider, 2016. Mixed-media installation with knotted fabric and beer bottles,
82 ⅝ × 275 ½ × 133 ⅞ in. (210 × 700 × 340 cm). Zeitz Museum of Contemporary Art Africa, Cape Town

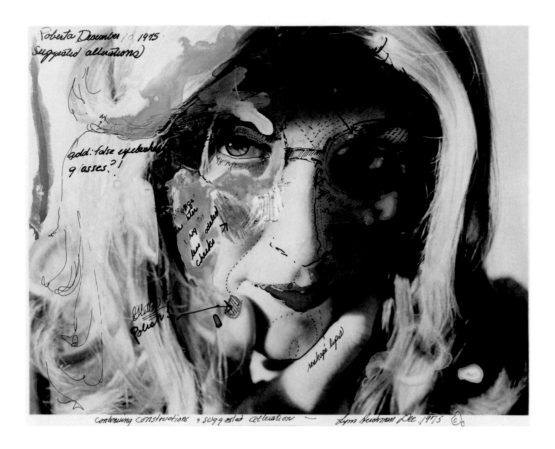

Lynn Hershman Leeson

(b. 1941 in Cleveland; lives in San Francisco) has explored issues of self-invention, surveillance, artificial intelligence, and genetic engineering long before they were fashionable. In her pioneering Roberta Breitmore role-playing project from 1974 to 1978, she brought to life an alter ego or avatar, complete with a blonde wig, loopy handwriting, her own driver's license, and romantic encounters on the streets of San Francisco. (Roberta later lived on in the virtual world of *Second Life*.) Hershman Leeson has also made a series of feature films and documentaries, including a pair of sci-fi films starring Tilda Swinton and the important feminist history *!Women Art Revolution* (2010).

Roberta Construction Chart #2, 1975. Chromogenic color print, printed 2003,
22 ¹⁵/₁₆ × 29 ⅝ in. (58.3 × 75.3 cm). The Museum of Modern Art, New York

Roger Hiorns

(b. 1975 in Birmingham; lives in London) stirs up a tornado of contradictions in his installations: the durable versus the ephemeral, mysticism versus rationalism, humanity versus technology. A fascination with the spectacle of death and decay runs through his work, which uses unlikely and sometimes unstable materials such as bovine brain tissue and juice. He also likes setting chain reactions into play. In *Seizure* (2008), Hiorns filled a condemned London apartment with 75,000 liters of copper sulfate solution, causing toxic but gorgeous blue crystals to grow throughout the space. For a more recent project, which reenvisions traditional funeral rites in the age of globalization, he has been burying decommissioned airplanes in various underground locations.

Untitled, 2012. Steel, engines, and copper sulphate, overall 114 ½ × 42 ½ × 49 ½ in. (290.8 × 108 × 125.7 cm).
Walker Art Center, Minneapolis

David Hockney

(b. 1937 in Bradford, England; lives in Los Angeles) is one of the most celebrated painters working today, delivering the sensual and colorful pleasures associated with early twentieth-century masters like Henri Matisse. His sparkling-blue swimming-pool paintings from the 1960s were initially labeled Pop Art because of their slickness and flatness, but he has proven more interested in portraiture and landscape than in themes of consumer culture. He has written and spoken extensively about the influence of "optics" on the history of Western art, arguing that painters in the Renaissance began using mirrors and other devices during the composition process to help create the illusion of depth, and his recent paintings feature startling experiments with linear perspective.

A Bigger Splash, 1967.
Acrylic on canvas, 96 × 96 in. (243.8 × 243.8 cm). The Tate, London

Candida Höfer

(b. 1944 in Eberswalde, Germany; lives in Cologne) is a leading figure in the Düsseldorf School of Photography, a group of artists who studied under Bernd and Hilla Becher. She creates vividly detailed, large-format color photographs of institutions around the world, in particular the public buildings designed to conserve and stage culture that could be called "cathedrals of knowledge." Her portraits of places like the Hermitage Museum in Saint Petersburg, Trinity College Library in Dublin, and La Scala in Milan are photographed devoid of visitors, drawing attention to their architectural and decorative splendor. This often-haunting work underscores the value of what is visually missing: the profoundly human experience of encountering art and architecture.

Palazzo Zenobio Venezia III, 2003. Chromogenic print, 59 ⅞ × 59 ⅞ in. (152 × 152 cm). National Museum of Women in the Arts, Washington, D.C.

Gary Hume (b. 1962 in Tenterden, England; lives in London and Accord, New York) originally came to notice in 1988, exhibiting his lifesized, brightly colored paintings of the doors of St. Bartholomew's Hospital alongside fellow Goldsmiths students who would soon become known as the Young British Artists, or YBAs. But from early on, Hume stood apart for being more thoughtful and less sensational, attentive to life's momentary pleasures and mundane disappointments even in his high-gloss images of celebrities such as Kate Moss and Michael Jackson. Recently, he has made more personal work about memory and family inspired by his mother's dementia. In this series, Hume shifted from using his usual aluminum panels to painting on paper, exploring the ripples and eddies produced by the paint reacting with the surface.

Little Whistler, 1996. Gloss paint on aluminum, 24 × 22 ⅜ in. (61 × 57 cm).
Bonnefanten Museum, Maastricht, The Netherlands

William Kentridge

(b. 1955 in Johannesburg; lives in Johannesburg) has examined the continued anguish of South Africa's colonial legacy and the relationship between social injustice and personal responsibility through a range of mediums, including stop-motion animated films. The making of these films, such as his celebrated series *Drawings for Projection* (1989–present) involves drawing, erasing, and redrawing scenes in charcoal, a process that hints at the continual drafting and redrafting of South Africa's cultural memory and national narrative in the aftermath of apartheid. Trained as a theater actor, Kentridge often returns to the world of performance, as in his productions of *The Magic Flute* (La Monnaie, Brussels, 2005), *Lulu* (Metropolitan Opera, New York, 2016), and *The Head & the Load* (Tate Modern, London, 2018).

Stereoscope, 1999. From the series *Drawings for Projection*, 1989–present.
Frame enlargement from a 16mm acetate print. George Eastman Museum

Suzanne Lacy (b. 1945 in Wasco, California; lives in Los Angeles) is a feminist artist and educator who coined the term "new genre public art" in 1991 to describe activist-driven artwork that takes place outside of the museum setting and directly involves a particular community. Now a more popular and recognized form of art making, this type of art is often identified as "social practice." Formally varied, Lacy's large-scale collaborative projects have explored such issues as rape in Los Angeles (*Three Weeks in May*, 1977, and *Three Weeks in January*, 2012), domestic violence in Ecuador (*De tu Puño y Letra*, or *By Your Own Hand*, 2014–17), and social tensions between Muslims and Christians in northwest England (*The Circle and the Square*, 2015–17).

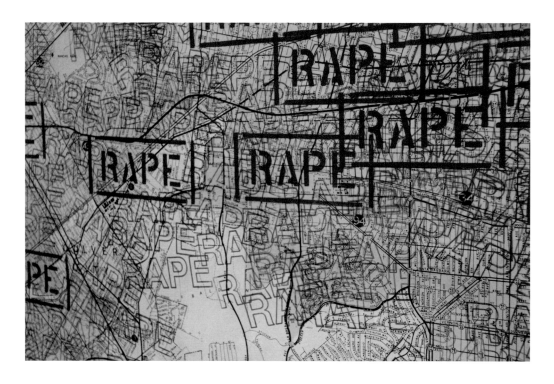

Three Weeks in May (detail), 1977.

Ink on printed maps and sound, six panels, dimensions variable. Hammer Museum, Los Angeles

Suzy Lake (b. 1947 in Detroit; lives in Toronto) uses provocative images of her own body to dislodge stereotypes about beauty, femininity, gender identity, and authority. Some of her photo-based series from the 1970s mimic and undercut the fashion "makeovers" so popular in women's magazines at the time, with one documenting her unsettling "transformations" into other people (darkroom magic, not Photoshop) and another using actual makeup on the surface of her self-portraits (Covergirl eye shadow included). A more aggressive series from 1976, *Choreographed Puppets*, documents a performance in which she hung from straps in a wooden structure as if she were a marionette, ceding control of her body to puppet masters (one was Bill Viola). Recent work examines the unflattering effects of aging, forcing viewers to confront their own obsessions with youth culture.

A Genuine Simulation of . . . #2, 1973–74. Six gelatin silver fiber-based photographs and commercial makeup, overall 27 ½ × 32 ½ in. (70 × 82.5 cm). The Montreal Museum of Fine Arts

Liz Magor

(b. 1948 in Winnipeg, Manitoba, Canada; lives in Vancouver, B.C.) is a sculptor best known for creating realistic casts of consumer goods in what seems like an attempt to rescue throwaway elements of our culture. But instead of using traditional casting materials like bronze, she often uses polymerized gypsum, which allows her to create objects supple enough to be confused for and combined with real things: a gypsum-cast ashtray holding a cast mouse plus a real cigarette and matches (2006); a gypsum-cast pile of stones sitting on top of a real heap of Cheetos (2000); or a cast paper bag containing real pompoms (2014). Her work sometimes inspires talk of simulacra, but Magor isn't interested in deconstructing notions of originality as much as helping us see the world, and overlooked objects like brown paper bags, with more complexity and subtlety.

Carton II, 2006. Polymerized gypsum, tobacco, gum, and matches,
11 ½ × 21 × 19 in. (29.2 × 53.3 × 48.2 cm). The Montreal Museum of Contemporary Art

Annette Messager

(b. 1943 in Berck-sur-Mer, France; lives in Malakoff, France) updates Surrealist techniques of fragmentation and dislocation to explore such issues as pain, pleasure, and gender oppression in her trenchant installations. Since the break-through work *The Boarders* (1971–72), in which she knitted tiny wool sweaters to clothe dead birds, some of her most distinctive elements include taxidermied animals, stuffed animals whole or cut up, sculpted human organs, and dismembered puppets, often brought together through some sort of netting. For the quasi-religious offering *Mes Voeux* (*My Vows*, 1988–91), she assembled numerous photographs of body parts. "For me, it's a 'natural' gesture to rip bodies apart, cut them up," she has said. "I always feel that my identity as a woman and as an artist is divided, disintegrated, fragmented."

Mes Voeux (My Vows), 1990. 24 gelatin silver prints, 14 handwritten text panels with color pencil on paper, and string, overall 30 ⅞ × 30 ¹¹⁄₁₆ in. (78.5 × 78 cm). National Gallery of Art, Washington, D.C.

Beatriz Milhazes

(b. 1960 in Rio de Janeiro; lives in Rio de Janeiro) uses a transfer technique to create her distinctive, highly stylized paintings, first painting on plastic sheets before peeling away the dried shapes and collaging them onto the canvas. The resulting works feature bright constellations of brushstroke-free patterns—floral designs are a favorite—that appear crisp and saturated with color. For these paintings, as well as her collages, prints, and installations, Milhazes draws on a wide range of aesthetic traditions, including folk art, European modernism, and Antropofagia, a movement founded in the late 1920s that proposed "cannibalizing" the supposedly high-minded European traditions to create a uniquely Brazilian culture.

Love, 2007. Acrylic on linen, 77 ⅛ × 97 ⅝ in. (196 × 248 cm).
São Paulo Museum of Modern Art

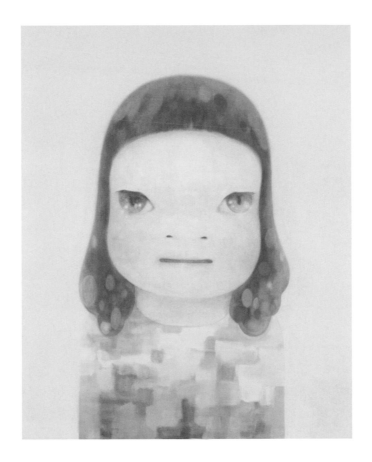

Yoshitomo Nara

(b. 1959 in Hirosaki, Japan; lives in Tokyo) has created in his paintings, drawings, and sculptures a small army of moody, wide-eyed children and animals. At first glance, these paintings, such as *The Girl with the Knife in Her Hand* (1991), seem innocent and reflective of *kawaii*, a Japanese ideal of childlike cuteness. But the young subjects in Nara's paintings carry weapons or smoke cigarettes, make melancholy or angry facial expressions, and sometimes bear slogans such as "silent violence." These figures, which can be read as a commentary on the challenges facing Japanese youth, reflect a range of artistic sources: not just the anime and manga comics that helped define the "Superflat" artists, with whom Nara is often grouped, but also punk and rock music and traditional Japanese Otafuku and Okame theatrical masks.

Miss Spring, 2012.
Acrylic on canvas, 89 ⅜ × 71 ⅝ in. (227 × 182 cm). Yokohama Museum of Art

Shirin Neshat

(b. 1957 in Qazvin, Iran; lives in New York) explores the complexity and beauty of Muslim culture in photographs, videos, and film. Much of her early work, such as the breakthrough series of photographs *Women of Allah* (1993–97), highlighted gender issues created by Islamic militancy and fundamentalism. More recent work has been less explicitly political and more poetic in its approach. One particular interest over the years has been the genre of the photo-portrait. She often writes on the surface of these portraits—adding calligraphic texts in Farsi that appear to be written on the body—as a way to give her subjects more of a voice. Neshat has also made two feature-length films: *Women Without Men* (2009), an adaptation of Shahrnush Parsipur's novel of the same name, and *Looking for Oum Kulthum* (2017), inspired by the legendary Egyptian singer.

Malala Yousafzai, 2018. Archival ink on gelatin silver print on fiber-based paper,
60 × 40 in. (152.4 × 101.6 cm). National Portrait Gallery, London

Tuan Andrew Nguyen

(b. 1976 in Saigon, now Ho Chi Minh City; lives in Ho Chi Minh City) organized in 2006 an art collective called The Propeller Group, which is known for plunging into the geopolitical fray and challenging national perspectives about media, politics, and war. Their popular 2011–12 video installation *Television Commercial for Communism* (TVCC), for instance, attempts to rebrand communism—it looks as Zen as a yoga studio—for a new generation. Nguyen also works independently and has recently made a dystopic short film *The Island* (2017), which he shot on Pulau Bidong, an island off the coast of Malaysia that became a massive refugee camp after the Vietnam War. In the film, it appears as "a place of spiritual refuge, a mythical character, and a floating battlefield of memories," says the artist.

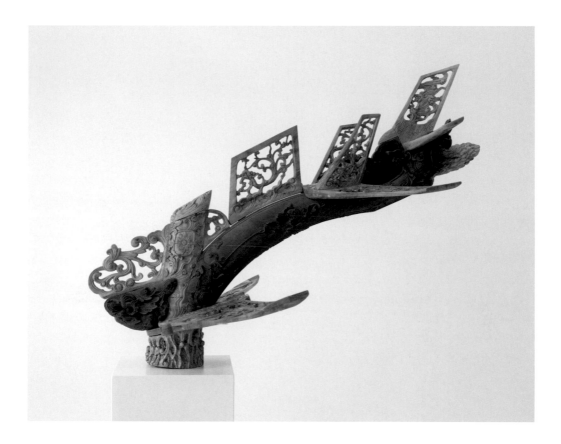

The Propeller Group (Tuan Andrew Nguyen, Phunam Thuc Ha, and Matt Lucero), *Antique Dragon Spacecraft*, 2016.
Hand-carved jackfruit wood and antique jackfruit wood column, 38 ½ × 47 ½ × 50 ½ in. (97.8 × 120.7 × 128.3 cm).
Asian Art Museum, San Francisco

Ahmet Öğüt

(b. 1981 in Diyarbakır, Turkey; lives in Amsterdam and Berlin) describes himself as a "sociocultural initiator, artist, and lecturer," which underscores the fact that he operates in, outside, and also on the contemporary-art system. With his *Silent University* (2012–ongoing), Öğüt created a forum for academics and professionals who are refugees, asylum seekers, or migrants to exchange ideas and information—many being unable to practice in their fields due to immigration restrictions. For *Fahrenheit 451: Reprinted* (2013), he worked with firemen in Helsinki to create a book-printing workshop inside a fire truck, culminating in the printing of 1,500 banned books. While his materials range widely, from photography and installation to a huge Magritte-inspired helium balloon, one through-line in Öğüt's art is his witty deflation of political or ethical injustices.

Mutual Issues, Inventive Acts: Simit Seller, 2008. Chromogenic print mounted on aluminum, 59 ¹⁄₁₆ × 39 ⅜ in. (150 × 100 cm). Kiasma–Museum of Contemporary Art, Helsinki

Gabriel Orozco (b. 1962 in Jalapa, Mexico; lives in Mexico City, Tokyo, and other cities) first gained attention internationally in the early 1990s for making art out of unlikely objects, whether oranges, soccer balls, yogurt cup lids, a Citroën car, or a gray plasticine ball that he rolled through the streets of Manhattan to pick up debris. He has since made colorful abstract paintings and drawings based on the geometry of circles and bisected circles, using systems that resemble chess moves and that update conceptual art strategies set in motion by Duchamp. Chance, games, and sports are all recurrent themes in Orozco's work. He mainly divides his time between Mexico City, Tokyo, and Bali, where he has begun making sculptures from local limestone.

Accelerated Footballs, 2005. 165 modified soccer balls, dimensions variable. Installation view from an exhibition at Experimental Museum El Eco, Mexico City, 2005. University Museum of Contemporary Art, Mexico City

Cornelia Parker

(b. 1956 in Cheshire, England; lives in London) has a history of breaking down and reconstituting familiar objects to unsettling effect. Whether steamrolling precious silverware for *Thirty Pieces of Silver* (1988–89) or rebuilding an American barn into a replica of the Bates mansion from the movie *Psycho* for *Transitional Object (PsychoBarn)* (2016), she helps to unpack the psychological baggage of common objects. One particular focus has been the violence inflicted by ballistics and explosives, and *Cold Dark Matter: An Exploded View* (1991) involved blowing up a garden shed with the help of the British army and then reconstructing it as it appeared mid-explosion inside an exhibition space. "I don't really make things from scratch," she once said. "I'd rather destroy something."

Hanging Fire (Suspected Arson), 1999. Charcoal, wire, pins, and nails, 144 × 60 × 72 in. (365.8 × 152.4 × 182.9 cm).
Institute of Contemporary Art, Boston

Mai-Thu Perret (b. 1976 in Geneva; lives in Geneva) has made her name exhibiting texts and artifacts from a feminist, anticapitalist commune in New Mexico—only the community is fictional. Invented by Perret in 1999, it has provided the subject and substance of an ongoing conceptual artwork titled *The Crystal Frontier*, which ranges from diary entries to ceramic sculptures, textiles, and other artifacts that the artist calls the commune's "hypothetical products." Along with exploring the potential of feminist utopias, the project raises questions about how inert objects can tell stories. Or, on the flip side, how can they resist a narrative framework as all-encompassing as *The Crystal Frontier*? This issue has come up with Perret's seeming departures from the project, like her 2016 lifesize sculptures representing real Kurdish female soldiers from the Women's Protection Unit. Their relationship to women of *The Crystal Frontier* is anything but clear.

Little Planetary Harmony, 2006. Aluminum, wood, drywall, latex wall paint, neon lights; interior: acrylic on wood, 139 × 262 × 143 ¾ in. (353 × 665 × 365 cm). Installation view from an exhibition at The Renaissance Society, University of Chicago, 2006. Aargauer Kunsthaus, Aarau, Switzerland

Bernard Piffaretti

(b. 1955 in Saint-Étienne, France; lives in Paris) begins his signature abstract paintings with a strong center line running vertically down the middle of the canvas, then composes brightly colored shapes and patterns on one half of the bisected canvas. Once finished with the first half, Piffaretti duplicates that image onto the other side, creating an imperfect copy of the original without any indication of which was painted first. By repeating his own work twice within one object, and thus drawing attention to each side's minute differences, Piffaretti subverts any hierarchy between original and reproduction. His visual stutter also upsets any linear notion of storytelling. "In my case, the duplication affirms the narrative power of expression and arrests it at the same time," the artist noted.

Untitled, 2016. Acrylic on canvas, 94 ½ × 78 ¾ in. (240 × 200 cm).
The Museum of Modern Art of the City of Paris

Ana Prvački

(b. 1976 in Pančevo, Yugoslavia, now Serbia; lives in Los Angeles) playfully and pointedly explores the underbelly of capitalist exchanges and the oddity of social etiquette in her performances and other artworks. For one 2016 series, *Stealing Shadows*, she exhibited and sold, at a specified fraction of what the original would cost, the "shadows" of famous artworks like a Louise Bourgeois spider and a Marcel Duchamp bicycle wheel. Trained as a classical flutist, she often uses music in her work, as in *Tent, Quartet, Bows and Elbows* (2007), which consisted of musicians performing in a small tent that rippled and bulged with their movements, a way of translating music into a new visual language.

Stealing Shadows (Duchamp), 2009. Mixed media, dimensions variable.
Museum of Contemporary Art, Los Angeles

Pipilotti Rist

(b. 1962 in Grabs, Switzerland; lives in Zurich) once compared the genre of video art to a woman's handbag with "room for everything: painting, technology, language, music, lousy flowing pictures, poetry, commotion, premonitions of death, sex, and friendliness." Her work has made room for all of these things, with rapturous pop music and colorful, hyper-feminized erotic fantasies among the most striking elements. One breakthrough video, *Sip My Ocean* (1996), is a trippy, underwater romp that intersperses shots of coral reef with bodies of female swimmers, digitally manipulated and multiplied to surreal effect, pulsating to a soundtrack of the artist singing Chris Isaac's "Wicked Game." Her recent room-sized installations have become even more immersive, with one consisting of 3,000 hanging LED lights that Rist has compared to "a digital image or television exploding in space."

I Want to See How You See (or a portrait of Cornelia Providoli), 2003. Still from a single-channel video.
Museum of Fine Arts, Boston

Julião Sarmento

(b. 1948 in Lisbon; lives in Estoril, Portugal) creates intellectually engaging and visually seductive paintings, drawings, and installations, often establishing a dialogue between positive and negative space that evokes dynamics of desire and withdrawal. His celebrated series of *White Paintings*, begun in the 1990s, are a bit of a misnomer, as the works, typically done on a background of white paint, combine photographs and text snippets with graphite drawings that show signs of erasure and rethinking. Architectural elements and the figure of a headless woman are recurring images. Sarmento's recent sculptures, installations, and performances take up similar themes, offering hints of bodies and flashes of desire that suggest the gallery or museum viewer is always, already, a voyeur.

Being Forced into Something Else, 1991. Polyvinyl acetate, pigment, acrylic gesso, and graphite on raw cotton canvas, 114 ½ × 105 ⅛ in. (291 × 267.2 cm). Van Abbemuseum, Eindhoven, The Netherlands

Mithu Sen

(b. 1971 in Burdwan, India; lives in New Delhi) has never met a hierarchy that she didn't want to subvert. Her highly provocative and often humorous work takes on issues of political power, female sexuality, Indian and Western cultural dynamics, and more. Once, she dismantled—she says "dismembered"—the Taj Mahal by drawing sections of it on different walls throughout the Zachęta National Gallery in Warsaw for its exhibition of next-generation Indian artists. Many of Sen's drawings and sculptures also feature organic materials such as teeth and hair, Freudian classics, to explore repressed sexual desires and bodily anxieties. Working against the commodity-based expectations of the art market and with a notion of "radical hospitality," Sen constantly switches mediums and sometimes even gives her work away. In one project, *Free Mithu* (2007), Sen exchanged artworks for love letters written by the potential "buyers."

Untitled, 2005, from the *Drawing Room* series. Mixed media on handmade paper, 22 × 30 in. (55.9 × 76.2 cm). Devi Art Foundation, Delhi

Stephen Shore

(b. 1947 New York; lives in Tivoli, New York) helped to change the history of photography when, along with contemporaries such as William Eggleston and Joel Meyerowitz, he introduced color into his work. He started early as a photographer. As a child, he had a makeshift darkroom at home. At fourteen, he sold three of his black-and-white photographs to Edward Steichen for the Museum of Modern Art in New York. In his twenties, he made the shift to color, showing scenes from everyday American life in garish-seeming detail. Shore's images from this period, taken during several cross-country road trips in the 1970s and published in *Uncommon Places* (1982) and *American Surfaces* (1999), capture sprawling parking lots, cheap motel rooms, and vernacular signage with a formal sensitivity and carefully crafted sense of spontaneity that still mark his work today.

Breakfast, Trail's End Restaurant, Kanab, Utah, 1973.
Chromogenic print, 6 ⅛ × 8 ¹/₁₆ in. (15.6 × 20.5 cm). San Francisco Museum of Modern Art

Shinique Smith

(b. 1971 in Baltimore; lives in New York) incorporates clothes, accessories, and other personal belongings into colorful, mixed-media paintings and sculptures. The items are typically bundled together with rope, ribbon, and, in her words, "care and intention." The fact that many of the garments are used gives the artist a way to address issues of American income inequality, personal memory, and spiritual transformation. Her 2018 solo exhibition *Refuge* at the California African American Museum in Los Angeles, which examined ideas of homelessness, featured a community donation center that doubled as a sculpture. By repurposing modest materials, Smith meditates on their "very long history"—as objects in global economies, castaways of former owners, and symptoms of American excess.

All this, and Heaven, 2009. Clothing, fabric, pillows, rope, ribbon, roller skate, trophy, books, and headboard, 60 × 65 × 55 in. (152.4 × 165.1 × 139.7 cm). Denver Art Museum

Mounira Al Solh

(b. 1978 in Beirut; lives in Beirut and Zutphen, The Netherlands) has been working to comprehend the almost incalculable impact of the Lebanese and Syrian civil wars, among other global conflicts, in intimate or individual terms. For a long-running series, *I strongly believe in our right to be frivolous*, begun in 2012, she makes quick, often same-day portraits of Syrian, Afghan, Bengali, Somali, and other displaced people that she meets in Beirut or in other cities. Most of these portraits, now in the hundreds, are ink or watercolor, with some images later embroidered. Several contain handwritten notes in the margins that evoke the losses these individuals have suffered. She also explored the personal cost of political events in the 2017 documenta by re-creating the bakery her family ran in Lebanon that supported people with special needs, until it was bombed during the Lebanese Civil War.

I strongly believe in our right to be frivolous #81, 2015.
Mixed-media drawing on legal paper, 11 ¼ × 8 ¼ in. (28.6 × 21 cm). Art Institute of Chicago

Kishio Suga

(b. 1944 in Morioka, Japan; lives in Itō, Shizuoka, Japan) is a central member of the Japanese art movement Mono-ha (meaning "School of Things"), which took off in the late 1960s. Working in a mode reminiscent of the earthwork artists in the United States, Mono-ha artists arranged elemental materials like stone, wood, rope, and sand in radically simple, ephemeral formations. Concerned with "the activation" of a space, Suga's work has long had a performative element as well, making the artist's decisive gesture of placing rocks here or leaning a plank of wood there—an important 1970 piece consisted of wood beams angled in open windows—integral to the work. Over the last few decades, Suga has also made a wide range of small assemblages or wall pieces, similarly meant to extract the particularity and materiality of the "things" in play.

Diagonal Phase, 1969/2012.

Wood and stones, 101 ½ × 171 × 48 in. (257.8 × 434.3 × 121.9 cm). Dia Art Foundation (on view at Dia:Beacon), New York

Do Ho Suh

(b. 1962 in Seoul; lives in Seoul, London, and New York) is famous for making sculptures of his former homes, many done at full scale and made of diaphanous fabric. He uses 3D scanning for the most ambitious of these works, such as the purple fabric re-creation of his Korean childhood home inside his first American home, shown in 2013 in Seoul, complete with detailed facades and window frames. At the same time, the use of gauzy material undermines the physical weight and solidity of a building much like our memory does, bringing issues of loss and longing to the surface. Suh's other works include *Some/One* (2001), a robe made entirely of military dog tags, and *Floor* (1997–2000), a large, grid-based glass floor that is held up by thousands of tiny human figurines. In different ways, both works examine the tension between individuality and collective identity.

Staircase-V, 2008. Polyester fabric and metal armature, dimensions variable.

Installation view from an exhibition at the Hayward Gallery, London, 2008. Thyssen-Bornemisza Art Contemporary, Vienna

Diana Thater

(b. 1962 in San Francisco; lives in Los Angeles) constructs immersive video installations that tend to explore the intersections of so-called civilized society and the natural world. Her videos transport viewers into a herd of zebras or to the abandoned buildings of Chernobyl, upsetting the assumed hierarchy that values humans above animals and the earth as well as drawing attention to the consequences of environmental destruction. By using multiple screens and exposing monitors and wires within exhibition spaces, Thater highlights the tension between the artificiality of technology and the natural world that she honors in her work.

Delphine, 1999. Five-channel digital color video with sound (projection), nine-monitor cube, light filters, and existing architecture. Installation view from an exhibition at Kulturkirche St. Stephani, Bremen, Germany, 2009. Art Institute of Chicago

Rirkrit Tiravanija

(b. 1961 in Buenos Aires; lives in Chiang Mai, Berlin, and New York) first caused a sensation in the art world in 1992 when he cooked and served Thai curry and rice to New York gallery visitors. This artwork, *Untitled (Free)*, helped to define the field of "relational aesthetics": art that brings the audience into the artwork, encouraging an experience of communion or community. Tiravanija called the work a commentary on the "cultural fragmentation" that occurs when artifacts like pots and stoves are taken out of their original kitchen context. Interested in the fragmentation and acceleration of information as well, he has made important "demonstration" drawings derived from news photographs. He has also painted provocative quotes like "Fear Eats the Soul" directly on the front pages of *The New York Times*: a headline to encompass all headlines.

untitled (the days of this society is numbered / December 7, 2012), 2014.

Acrylic and newspaper on linen, 87 × 84 ½ in. (221 × 214.6 cm). The Museum of Modern Art, New York

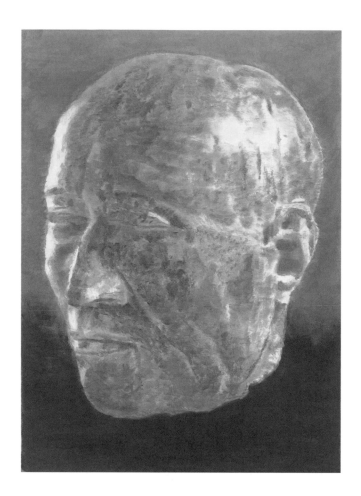

Luc Tuymans

(b. 1958 in Mortsel, Belgium; lives in Antwerp) helped to revive figurative painting in the 1990s by infusing it with the weight of war, political history, and personal responsibility. His paintings are often recognizable for their drab gray-and-brown color palette, their odd cropping of subjects, and their slightly out-of-focus appearance, all of which makes the images look secondhand or mediated. And they are. Interested in reexamining acts of violence associated with Belgian colonial history, the Holocaust, and the post-9/11 political climate, Tuymans usually bases his images on magazine or newspaper photographs or, increasingly, his own iPhone photos and online sources. What isn't discussed quite as often is how obliquely he addresses these historical topics, reflecting a distrust of imagery and a keen sense of the limitations of painting.

Ignatius of Loyola, 2006.
Oil on canvas, 44 ½ × 32 in. (113 × 81.5 cm). The National Museum of Art, Osaka

Bill Viola

(b. 1951 in New York; lives in Long Beach, California) has brought something of the beauty and gravity of Old Master paintings to the relatively new genre of video art. His themes, too, tend to the universal: birth, death, rebirth, and the meaning of human consciousness, often framed through an understanding of Zen Buddhism, which he studies and practices. His 2014 commission for St. Paul's Cathedral in London, *Martyrs (Earth, Air, Fire, Water)*, is a four-channel video that draws on the four elements to convey an acceptance of death in the face of the most powerful forces of nature. His wife Kira Perov, who runs his studio, is a longtime collaborator.

Ascension, 2000. Video/sound installation: color video projection on wall in dark room, stereo sound, 10 minutes; projected image: 98 × 138 in. (249 × 350 cm). Performer: Josh Coxx. The Museum of Fine Arts, Houston

Edmund de Waal

(b. 1964 in Nottingham, England; lives in London) plays with notions of presence and absence, as well as singularity and multiplicity, in his exquisite, hand-thrown ceramics and his thoughtful arrangements of them. Most dramatically, for his 2009 installation *Signs & Wonders* at the Victoria and Albert Museum in London, he placed 425 white and celadon porcelain vessels in a highly rhythmic arrangement high up on a glossy red shelf encircling the cupola above the ceramics gallery. Best known for working with white and celadon glazes, de Waal has recently experimented with black glazes. He has written several books, including the bestselling memoir *The Hare with Amber Eyes: A Hidden Inheritance* (2010), about his family inheritance of the small Japanese sculptures known as netsuke.

Signs & Wonders (detail), 2009. 425 porcelain vessels on a red aluminum shelf,
121 ft. 4 in. × 15 ¾ in. × 6 ⁵⁄₁₆ in. (3700 × 40 × 16 cm). Victoria and Albert Museum, London

Gillian Wearing

(b. 1963 in Birmingham; lives in London) uses video and photography to examine the presentation and performance of identity. In one of her most famous series, *Signs That Say What You Want Them to Say and Not Signs That Say What Someone Else Wants You to Say* (1992–93), Wearing photographed strangers with phrases they chose to write on blank white paper—often confessional and at odds with their appearance. For other works, Wearing has donned realistic latex masks of family members to create "self-portraits" that at once conceal and reveal, exploring the constructed and composite nature of identity. In 2018, she created the first sculpture of a woman in London's Parliament Square, commemorating the suffragist Millicent Fawcett.

Self-Portrait at Three Years Old, 2004. Chromogenic print, 71 ⅞ × 48 ¹⁄₁₆ in. (182 × 122 cm). Solomon R. Guggenheim Museum, New York

Lawrence Weiner

(b. 1942 in New York; lives in New York and Amsterdam) is a sculptor who began working with language in the 1960s when he recognized that language was sufficient to realize an artwork. His texts have appeared on the walls of galleries, museums, and other buildings and in various media such as books, posters, lyrics for music, and dialogue in movies. Weiner is especially drawn to working in public spaces, which he connects to growing up in the South Bronx without easy access to art. "I didn't have the advantage of a middle-class perspective," he has said. "Art was something else; art was the notations on the wall, or the messages left by other people. I grew up in a city where I had to read the walls; I still read the walls. I love to put work of mine out on the walls and let people read it."

CADMIUM & MUD & TITANIUM & LEAD & FERROUS OXIDE & SO ON . . ., 1991/2016.
Language + materials referred to, dimensions variable. Dia Art Foundation (on view at Dia:Beacon), New York

James Welling

(b. 1951 in Hartford, Connecticut; lives in New York) combines darkroom and digital experimentation in his work. He first became known in the early 1980s for abstract photographs of crumpled aluminum foil (1980–81) and velvet sprinkled with phyllo dough (1980) where the actual material is almost impossible to identify. He has also created several architectural series, such as gelatin silver prints of the stone facades of H. H. Richardson's buildings (1988–94) and vibrantly colored inkjet prints of Philip Johnson's iconic Glass House (2006–9). For the latter, Welling used colored gels in front of his camera to explore how color can define and also profoundly complicate form. "I enjoy operating between representation and abstraction, creating conditions where you don't really know what you're looking at," he has said.

5912, 2008. Inkjet print, 40 ¾ × 57 ⅜ in. (103.5 × 145.7 cm).
Cincinnati Art Museum

Acknowledgments

From the start, my goal has been to create a highly accessible book about art: one for the art-curious as well as the art world. I'd like to thank the editorial and production team at DelMonico Books/Prestel for sharing and supporting this vision.

I'm grateful for the beautifully inviting designs of Mark Melnick, the strong line-editing of Philomena Mariani, and the scrupulous photo research and project management by Katherine Churchill and Sophie Golub, with assistance from Anne Wu, Katie Hands, and Emma Kennedy. Most of all, *It Speaks to Me* benefited from wise guidance at key stages from my publisher Mary DelMonico. I've long heard from museum colleagues that she is the best in the business, and I can now happily vouch for this myself.

When the book was still in the early stages of development, I received great support from friends and family: Patricia Bannan, Mo Clancy, Beverly Creed, Vicky Curry, Noel Daniel, Todd Finkel, Lauri Firstenberg, Jona Frank, Alexandra Grant, Daniel Horch, Ellen Lubic, Michelle Marquart-Finkel, Janice Martin, Terry Martin, Andy Richard, Leslie Rubinoff, Nadya Sagner, Kim Schoenstadt, Karen Spector, Karen Zelmar, Marcy Zelmar, and, above all, my husband Michael Lubic. Lloyd J. Jassin helped me navigate the contractual process.

I'd like to thank Ashley Rawlings, director of Blum & Poe in Tokyo, for his help translating Kishio Suga's and Yoshitomo Nara's interviews from the Japanese, and Herbert Burkert for assisting with moments of the Candida Höfer conversation. Apart from two interviews I conducted in French, the remainder were done in English. I edited all for clarity with input from the artists.

For their invaluable help in lining up interviews or reaching out to artists, I'm also grateful to: Anthony Allen, Malena Bach, Mariana Baldi Halfeld Amorim, Silvia Baltschun, Ian Berry, Carole Billy, Jennifer Bindman, Tim Blum, Tanya Bonakdar, Bram Bots, Rebecca Boyle Suh, Frish Brandt, Brian Butler, Mary Leigh Cherry, Rebekah Chozick, James Cohan, Jane Cohan, Amy Cosier, Maisey Cox, Stephanie Dorsey, Tate Dougherty, Nike Dreyer, Eloísa Ejarque, James Elaine, Cecilia Fajardo-Hill, Bob Faust, Bruce Ferguson, Peter Fetterman, Danielle Forest, Rashell George, Alexie Glass-Kantor, Marian Goodman, Elyse Goldfinch, Jean-Pierre Gonçalves de Lima,

Michael Govan, Christopher Grimes, Cheryl Haines, Caroline Hoffman, Max Hollein, Curt Holtz, Florie Hutchinson, Sarvia Jasso, Catriona Jeffries, Jemima Johnson, Sam Kahn, Emily-Jane Kirwan, Lisa Kohli, Marie Krauss, José Kuri, Darryl Leung, Rose Lord, Jona Lueddeckens, Mónica Manzutto, MaryJo Marks, Philip Martin, Meriwether McClorey, Lissa McClure, Anne McIlleron, Deborah McLeod, Lisa Melandri, Jennifer Mora, Fabiana Motta, Kurt Mueller, Michelle Newton, Linda Pellegrini, Kira Perov, Allegra Pesenti, Laura Pomari, Ravi Rajan, Julie Roberts, Adrian Rosenfeld, Emily Ruotolo, Mary Sabbatino, Ed Schad, Anette Schäfer, Andrea Schwan, Marc Selwyn, Jessica Silverman, María Sprowls Cervantes, Nadine Stenke, Anna Stothart, Niklas Svennung, Junette Teng, Giulia Theodoli, Ben Thornborough, Laura Turcan, Vanessa Van Obberghen, Kara Vander Weg, Lisa Varghese, Susanne Vielmetter, Julia Villaseñor, Kai Vollmer, Lauren Wittels, Janine Wixforth, Julia Wunderlich, and Gene Zazzaro.

And for their assistance supplying images, captions, or biographical information: Hamid Amini, Victoria Arbour, Rebecca Ashby-Colón, Anna Ayeroff, Catherine Belloy, Paula Vicente Benito, Rob Berg, Kate Blake, Allison Brainard, Camille Brown, Hope Dickens, Martha Fleming-Ives, Ali Giniger, Curtis Glenn, Hans Hemmert, Symone Jordan, Jin Jung, Catherine Koutsavlis, Anna Kraft, Ali MacGilp, Akshar Maganbeharie, Alena Marchak, John Marchant, Lisa McCarthy, Ruth Phaneuf, Tracy Powell, Chelsea Ramirez, Chris Rawson, Calvin Reedy, Cristina Rodríguez, Sophie de Saint Phalle, Sven Christian Schuch, Megan Schultz, Susan Sherrick, Shalmali Shetty, Laura Steele, Francesca Szuszkiewicz, Anabel Wold, and Penny Yeung.

When I was on staff as an arts reporter at the *Los Angeles Times* from 2010 to 2013, I regularly covered breaking news about museums. It wasn't all good news. I spent a fair amount of time investigating financial crises and ethical lapses at these institutions. It was early during this period that I started interviewing L.A. artists on local museum pieces—a reminder of why we care about museums in the first place.

My deepest appreciation goes to my editors Kelly Scott, Craig Turner, and Sallie Hofmeister and designer Wes Bausmith for creating a platform for my column at that time. Thanks to Erica Varela, of the *Los Angeles Times* Rights & Permissions department, for granting permission for me to reprint these interviews, five of which are published here in expanded and revised form.

And lastly I'd like to thank all of the artists who generously shared their time and insights with me, including dozens who did interviews for the *Los Angeles Times* column not included in this book. I truly hope there will be a sequel.

—Jori Finkel

Museum Credits

Photograph Credits

Published in 2019 by DelMonico Books · Prestel

DelMonico Books, an imprint of Prestel, a member of Verlagsgruppe Random House GmbH

PRESTEL VERLAG
Neumarkter Strasse 28, 81673 Munich

PRESTEL PUBLISHING LTD.
14-17 Wells Street, London W1T 3PD

PRESTEL PUBLISHING
900 Broadway, Suite 603, New York, NY 10003

www.prestel.com

The interviews with John Baldessari, Mark Bradford, Suzanne Lacy, Diana Thater, and Bill Viola
originally appeared in shorter form in the *Los Angeles Times*.
© 2011, 2012, and 2013 *Los Angeles Times*. Used with Permission.

p. 2: detail of Pieter Jansz. Saenredam, *The Interior of the Grote Kerk at Haarlem,* 1636–37; see pp. 104–5
p. 6: detail of Agnes Pelton, *Awakening: Memory of Father,* 1943; see pp. 30–31

LIBRARY OF CONGRESS CATALOGING-IN-PUBLICATION DATA
Names: Finkel, Jori, interviewer.
Title: It speaks to me : art that inspires artists / Jori Finkel.
Description: Munich ; New York : DelMonico Books/Prestel, 2019.
Identifiers: LCCN 2018047211 | ISBN 9783791356594 (hardcover)
Subjects: LCSH: Artists—Psychology. | Artists—Interviews. | Creation
(Literary, artistic, etc.)—Interviews.
Classification: LCC N71 .F565 2019 | DDC 700.92/2—dc23
LC record available at https://lccn.loc.gov/2018047211

Edited by Philomena Mariani
Designed by Mark Melnick
Production management by Anjali Pala
Editorial coordination by Katherine Churchill,
Sophie Golub, and Katie Hands
Printed in China

ISBN: 978-3-7913-5659-4

A CIP catalogue record for this book is available from the British Library